Laurence Stephen
LOWRY
1887-1976

a catalogue of
The Salford Collection

from Salford Art Gallery,
Swinton Memorial Art Gallery
and Monks Hall Museum

Published by the City of Salford Cultural Services Department
Designed and printed in Great Britain by Lund Humphries
© 1977 City of Salford Cultural Services Department
ISBN 0 901952 07 9

Cover: No.51, *Yachts*, pastel, 1920.

Contents

City of Salford Cultural Services Committee 1977–78

His Worship the Mayor	Councillor S. Martin
Chairman	Councillor W. Jackson
Vice-Chairman	Councillor L. Shaw
Committee	Councillor C. J. Brooks
	Councillor Mrs. J. Catlow
	Councillor A. Cooper, J.P.
	Councillor T. A. Crellin
	Councillor D. I. Hall
	Councillor T. J. A. Harding
	Councillor J. Hill
	Councillor J. W. Hincks, J.P.
	Councillor W. Holmes
	Councillor Mrs. N. Openshaw
	Councillor J. Sharrock
	Councillor J. R. Thomas
	Councillor H. Wrigley
Chief Executive	R. C. Rees, M.A., LL.B.
Cultural Services Manager	M. W. Devereux, F.L.A., F.R.S.A.
Assistant Manager (Curator of Art Galleries and Museums)	S. Shaw, F.M.A.

Preface

The City of Salford possesses a national heritage in its representative collection of works by the late L. S. Lowry. The existence of the collection and associated reference material is due in no small measure to the artist's generosity and to the discernment of elected members and officers of the former Salford, Swinton & Pendlebury and Eccles borough councils, with whom Mr. Lowry enjoyed warm and lasting friendships. In particular the late A. J. M. Maltby, the late A. Frape, and S. Shaw, successively Directors of Salford Art Gallery, and the late Gerald B. Cotton, formerly Borough Librarian of Swinton & Pendlebury, did much in helping to acquire what is now the largest permanent collection of the artist's work.

In his later life, Mr. Lowry often recalled memories of his many years at Pendlebury and his solitary walks across the nearby Swinton and Clifton mosslands where he made so many early drawings and sketches.

It was at Pendlebury that he first conceived his paintings of the industrial environment of South East Lancashire, an environment which he never left, even in his later years at Mottram-in-Longdendale, nor during his extensive travels throughout the British Isles or his frequent sojourns in the North East.

It was a rare and unforgettable privilege to have known Mr. Lowry, and it is a further privilege to introduce this, the first complete record of the Salford Collection. It could not have been produced without the work of many people. Frank Mullineux of Worsley, formerly Keeper of Monks Hall Museum, happily agreed to contribute original studies of Mr. Lowry as a man, and as an artist, based upon the extensive notes which he and his wife Elsie, together with Gerald Cotton, made of meetings, interviews and conversations with Mr. Lowry, over many years. Stanley Shaw, Assistant Cultural Services Manager and Curator, and Michael Leber, Art Exhibitions Officer, compiled the entries and selected the illustrations with the assistance of Mrs. Judith Sandling, Assistant Exhibitions Officer, and Mrs. Marianne Hunter, Keeper of Fine Art. Messrs. Lund Humphries, the printers, gave invaluable technical advice. Harold Riley, a good friend of Salford Art Gallery, has kindly given permission to reproduce the photograph of Mr. Lowry.

The publication of the catalogue would not have been possible but for the encouragement and support of the Chairmen and Members of the Finance and Cultural Services Committees, and of the Chief Executive.

It is hoped that this catalogue will make a significant contribution to the full appreciation of a local artist of international importance who, through his lifetime's work, has yet so much to say to this and to future generations.

MICHAEL W. DEVEREUX

Chronology

1885 Parents moved from Liverpool to Manchester. Lived at 8 Barrett Street, near Stretford Road, Stretford.

1887 1 November. Laurence Stephen Lowry born at 8 Barrett Street, Stretford

1893 By this date parents living at 4 Ellesmere Place, near Stockport Road, Longsight, Manchester.

1895 Began attending Victoria Park School, Manchester.

1898 Moved to 14 Pine Grove, Longsight.

1904 Began work as a clerk with Thomas Aldred and Son, Chartered Accountants, 88 Mosley Street, Manchester.

1905–6 Began attending evening classes at the Manchester Municipal College of Art. Took post of Claims Clerk with General Accident, Fire and Life Insurance Corporation, 20 Cross Street, Manchester.

1909 1 May. With his parents, moved to 117 Station Road, Pendlebury, Swinton.

1910 Took post of Rent Collector and Clerk with Pall Mall Property Co. Ltd, Manchester.

1915 Began attending evening classes at the Salford School of Art.

1918 Student member, but elected to exhibit for one year only, of the Manchester Academy of Fine Art.

1919 A drawing and two paintings exhibited at the Manchester Academy of Fine Art.

1921 With two others, exhibited in the offices of an architect, Roland Thomasson, 87 Mosley Street, Manchester. Sold his first picture, a pastel, *The Lodging House* (No. 53) (L. S. Lowry considered this to be the first real exhibition).

1925 Pictures included in the Manchester Society of Modern Painters exhibition at their new headquarters, 33 Blackfriars Street, Manchester.

1926–30 Pictures exhibited in Manchester, in Japan and at the Paris Salon d'Automne.

1927–36 Each year exhibited with the New English Art Club, then on and off, until 1957.

1930 Asked by Mrs. Timperley to illustrate her husband's book *A Cotswold Book* by Harold Timperley, published 1931 by Jonathan Cape.
Took part in exhibition by Six Art Clubs in Manchester. One picture by L. S. Lowry, *An Accident*, purchased by Manchester City Art Gallery.
Exhibited drawings at a one-man exhibition at the Annual Meeting of the University Settlement in the Round House, Every Street.

1931 Pictures in Salford Artists exhibition at Salford City Art Gallery.

1932 Father died in February.
Again exhibited at the Manchester Academy of Fine Art and did so yearly with very few exceptions until 1972.
First exhibited at the Royal Academy of Arts.

1933 Exhibited with the Royal Society of British Artists.

1934 Elected a member of the Royal Society of British Artists.

1936 Pictures in a mixed exhibition at the Arlington Gallery, London. *A Street Scene, St. Simon's Church*, 1928 (No. 102) purchased by Salford Art Gallery from Manchester Academy exhibition.

1938 A. J. McNeil Reid of the Lefevre Gallery, London noticed some of Lowry's paintings at the premises of James Bourlet and Sons, Ltd, Picture Framers, London.

1939 Mother died.
First one-man exhibition at the Lefevre Gallery. From 1943 one-man exhibitions held at the same gallery at one, two and three yearly intervals until 1976.

1941 One-man exhibition at the Salford City Art Gallery.

1943 One-man exhibition in the Bluecoat Chambers, Liverpool.
Exhibited at 117A Oxford Road, Manchester with the Manchester Ballet Club from which the Manchester Art Club was formed in 1946.

1945 Honorary Degree of Master of Arts conferred by the University of Manchester.

1946 Some of the members of the Manchester Art Club, including L. S. Lowry, formed an

inner circle, the Manchester Group, which exhibited at the Mid-day Studios, 96 Mosley Street, and at other addresses until 1956.

1948 Lived for a few months at 72 Chorley Road, Swinton.
Moved to The Elms, 23 Stalybridge Road, Mottram-in-Longdendale, Cheshire.
Became a member of the London Group.
One-man exhibition at the Mid-day Studios.

1950 Exhibited in *Painters' Progress* at the Whitechapel Art Gallery, London.

1951 Retrospective exhibition at the Salford City Art Gallery.
Exhibited in *British Painting 1925–1950*, an Arts Council Touring Exhibition.
With Theodore Major exhibited in *Two Lancashire Painters*.

1952 First exhibition at a provincial private gallery, the Crane Gallery, Manchester and at the same gallery in 1955 and 1958.
This gallery moved to London and regularly held exhibitions of the artist's work.
Retired on full pension from The Pall Mall Property Company, Manchester with whom he held the post of chief cashier.

1955 Two-man exhibition with Josef Herman at the Wakefield Art Gallery.
Elected Associate of the Royal Academy of Arts.

1959 Retrospective exhibition Manchester City Art Gallery.
Pictures in the British Group exhibition at the Robert Osbourne Gallery, New York.

1960 Exhibition at the Altrincham Art Gallery.
Exhibition at the Harrogate Festival of Visual Arts.
Pictures from the Rev. Geoffrey Bennett Collection exhibited at Middlesbrough Art Gallery and in 1961 at the Laing Art Gallery, Newcastle upon Tyne.

1961 Honorary Degree of LL.D. conferred by the University of Manchester.
Exhibition at the opening of Monks Hall Museum, Eccles.
Exhibition at Swinton and Pendlebury Public Library.

1962 Elected full member of the Royal Academy of Arts.
Retrospective exhibition held at the Graves Art Gallery, Sheffield.

1964 An exhibition *A Tribute to L. S. Lowry* at Monks Hall Museum, Eccles. Twenty-five contemporary artists sent works as their tributes to mark the 77th birthday of L. S. Lowry.
The Hallé Concerts Society marked his birthday with a special orchestral concert in Manchester on Sunday, 1 November – the first time a painter had been so honoured.
Exhibition at the Stone Gallery, Newcastle upon Tyne, of paintings from the Monty Bloom Collection.
Exhibition at the Swinton & Pendlebury Public Library.
Pictures in *The Englishness of English Painting* exhibition at The Robert Osbourne Gallery, New York.

1965 Freedom of the City of Salford conferred.

1966 Voted 'Man of the Year' by Manchester Junior Chamber of Commerce.
Exhibition at Monks Hall, Eccles of pictures from the Monty Bloom Family Collection.
Arts Council Retrospective Exhibition toured a number of provincial galleries in 1966 and finished at the Tate Gallery in January, 1967.

1967 G.P.O. issued a stamp showing an industrial scene by L. S. Lowry.
Exhibition at the Stone Gallery, Newcastle upon Tyne.
Exhibition at the Magdalene Street Gallery, Cambridge.
Exhibition at the Playhouse, Nottingham.
Enlarged permanent exhibition at Salford City Art Gallery.

1968 Exhibition at Mottram-in-Longdendale.

1970 Exhibition at the new Swinton Art Gallery.
Exhibition, *The Drawings of L. S. Lowry 1923–65* at the Tib Lane Gallery, Manchester.
Exhibition at the Norwich Castle Museum of pictures from the Salford City Art Gallery collection.
Two pictures included in an Arts Council exhibition, *Decade, 1920–1930* which toured the provinces.

1971 Exhibition at Belfast organized by the Northern Ireland Arts Council.
Exhibition at the Haworth Art Gallery, Accrington.

1972 Exhibition at the Turnpike Gallery in the the Leigh Public Library.
Exhibition at the Hamet Gallery, London.

1973 Exhibition at the Walker Art Gallery,
 Liverpool to celebrate the 125th
 anniversary of the Liverpool Trades
 Council.
 The Arts Council toured the film *L. S.
 Lowry: Industrial Artist* made by
 Contemporary Films.

1974 Exhibition at Nottingham University Art
 Gallery.
 Exhibition of the Ives Collection at
 Whitworth Art Gallery.

1975 Honorary Degree of D.Lit. conferred by
 the University of Salford.
 Honorary Degree of D.Lit. conferred by the
 University of Liverpool.

1976 Died 23 February at Woods Hospital,
 Glossop, following an attack of pneumonia.

September: Large and comprehensive
retrospective exhibition at the Royal
Academy, London.
Exhibition at the re-designed Museum and
Art Gallery, Wigan.

1977 Exhibition at the Manchester City Art
 Gallery, *A Pre-Raphaelite Passion*. Twenty-
 three paintings and drawings from
 L. S. Lowry's private collection (fifteen by
 Rossetti, one by Ford Madox Brown).
 Also at the same time and place, an
 exhibition of the works of L. S. Lowry in the
 Manchester City Art Gallery Collection.
 A new Exhibition at the Salford City Art
 Gallery including 67 works from the estate
 of the artist.
 Exhibition at Mottram-in-Longdendale
 and at Stalybridge Art Gallery.

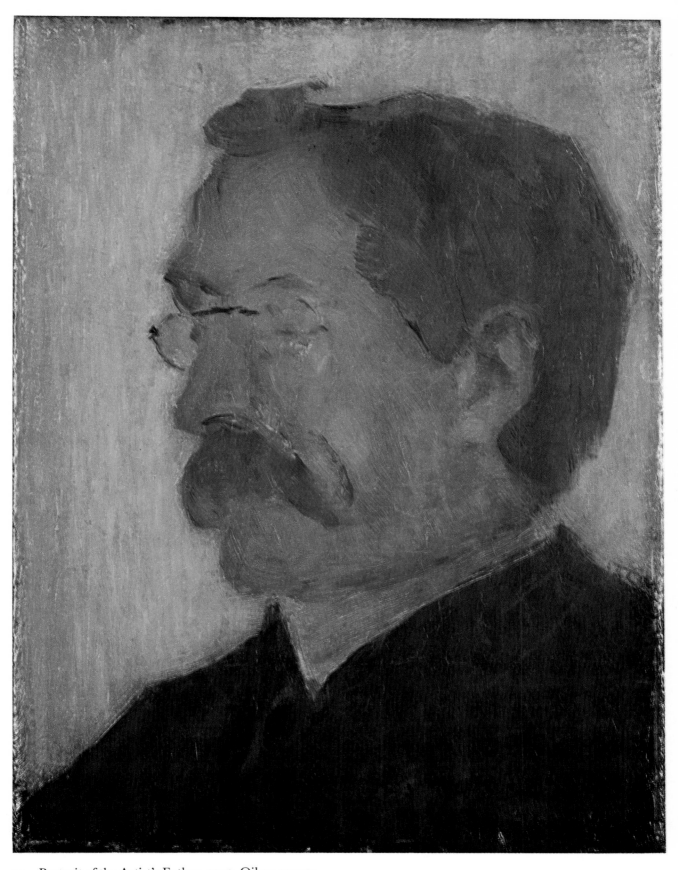

15 Portrait of the Artist's Father, 1910. Oil on canvas

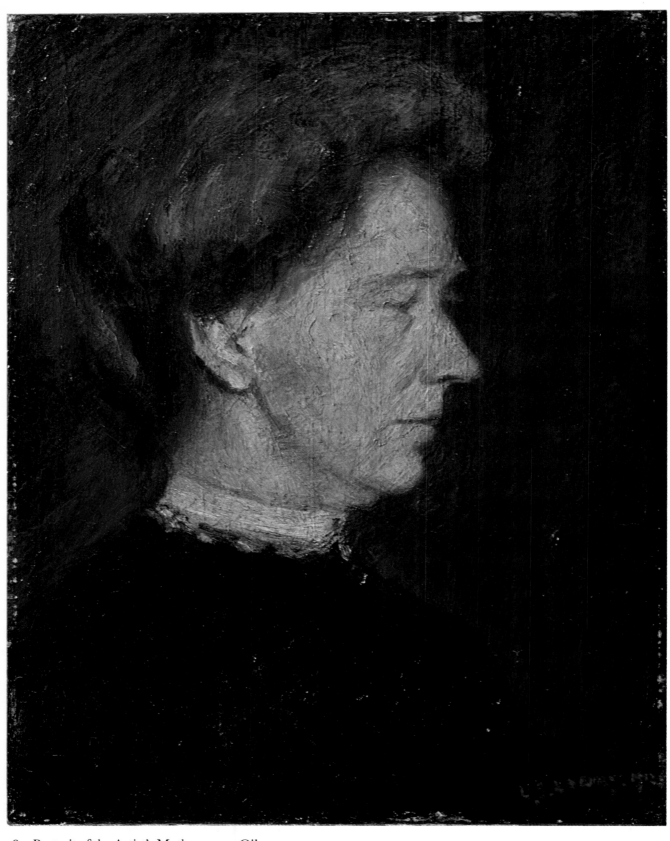

18 Portrait of the Artist's Mother, 1912. Oil on canvas

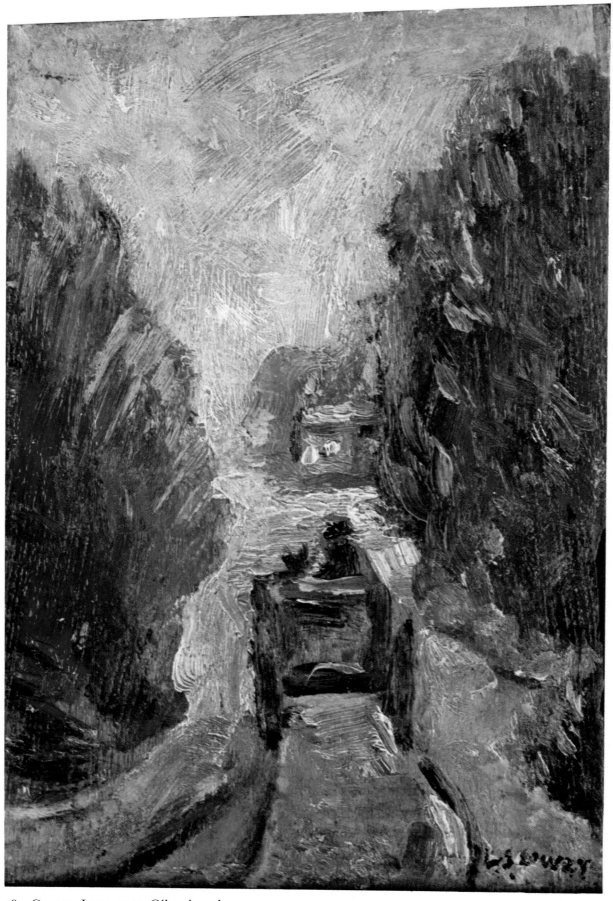

28 Country Lane, 1914. Oil on board

51 Yachts, 1920. Pastel

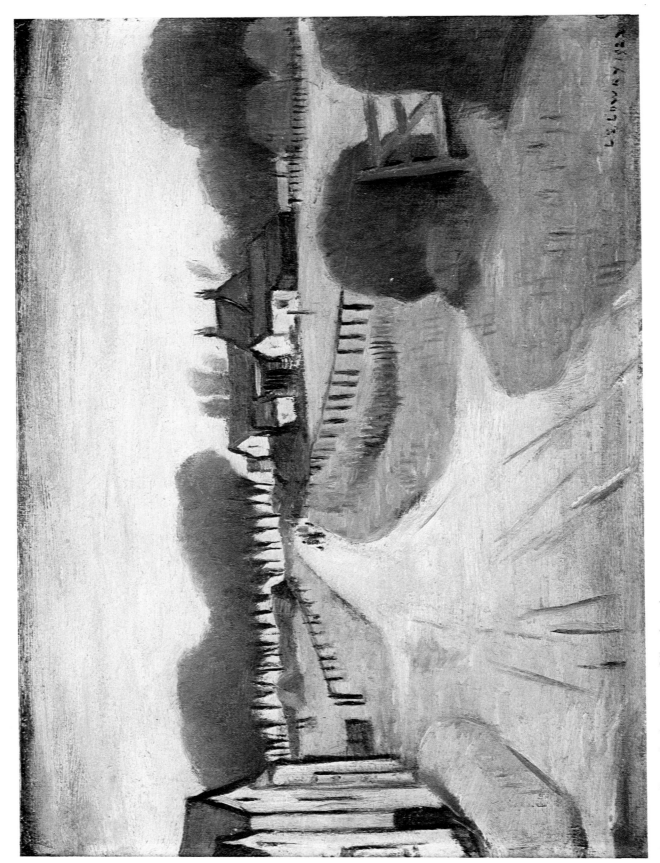

56 Regent Street, Lytham, 1922. Oil on board

13

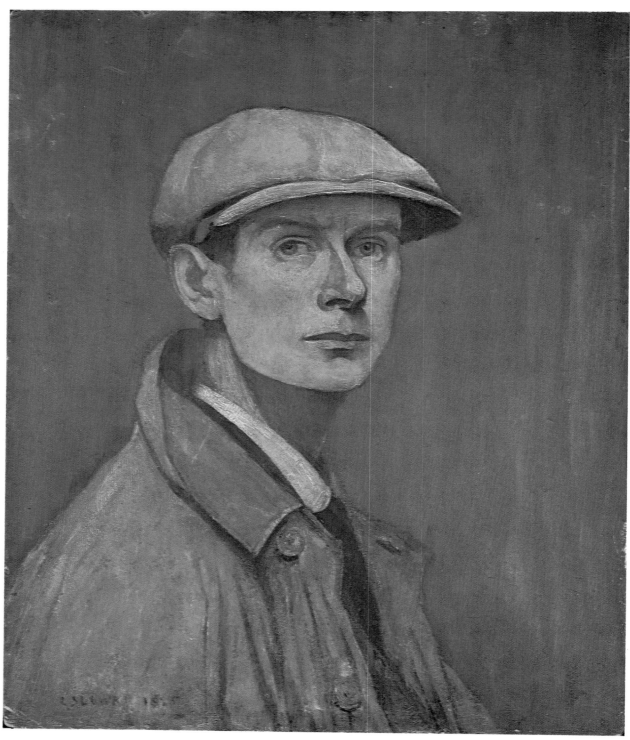

65 Self Portrait, 1925. Oil on board

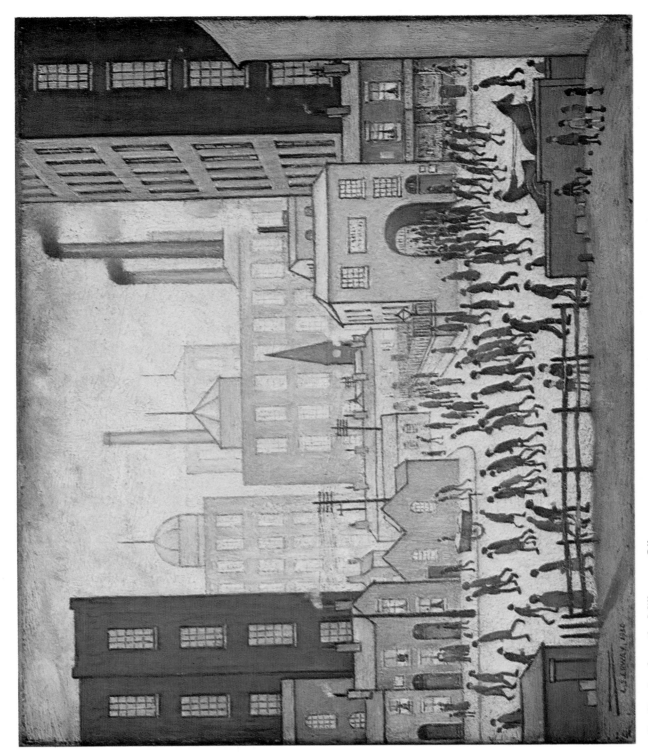

108 Coming from the Mill, 1930. Oil on canvas

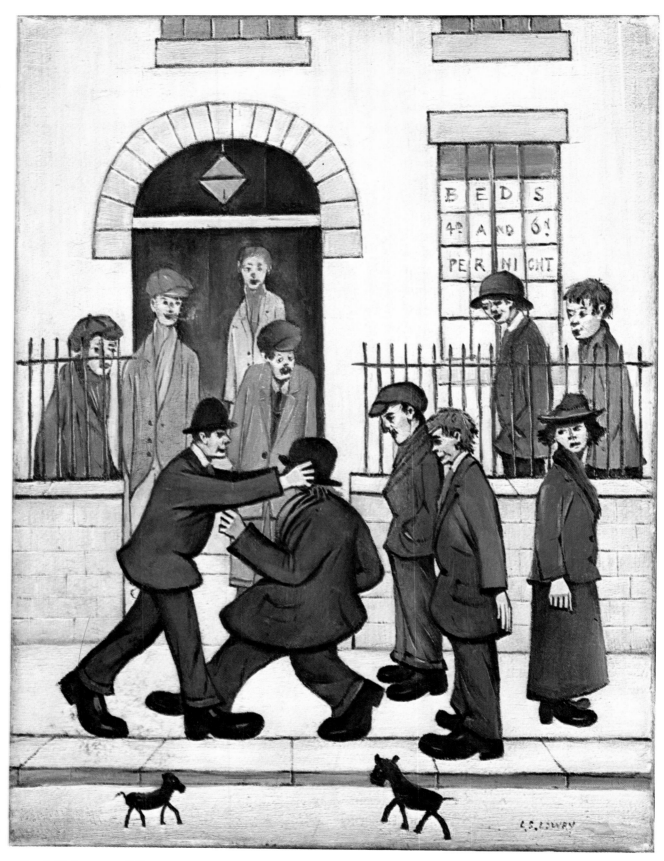

118 A Fight, 1935. Oil on canvas

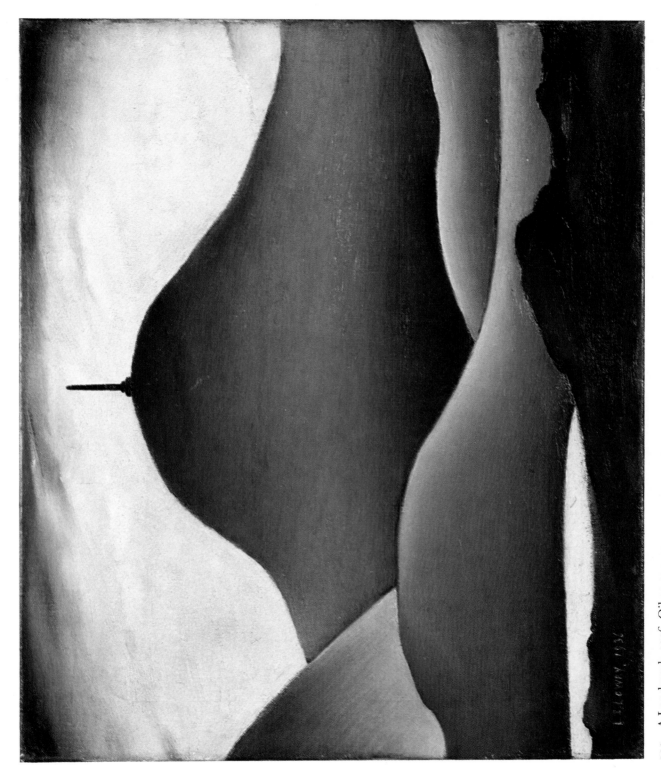

119 A Landmark, 1936. Oil on canvas

120 The Lake, 1937. Oil on canvas

18

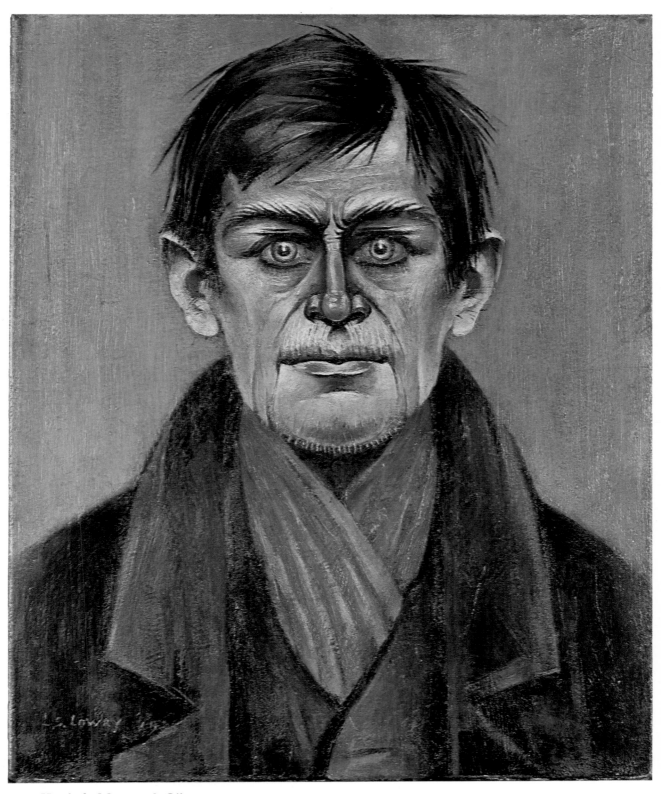

122 Head of a Man, 1938. Oil on canvas

123 Market Scene, Northern Town, 1939. Oil on canvas

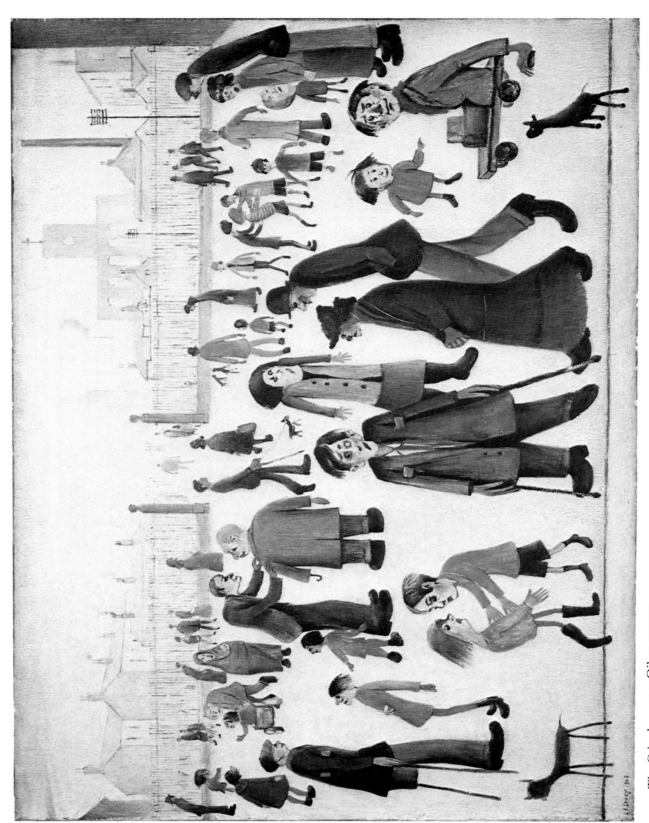

129 The Cripples, 1949. Oil on canvas

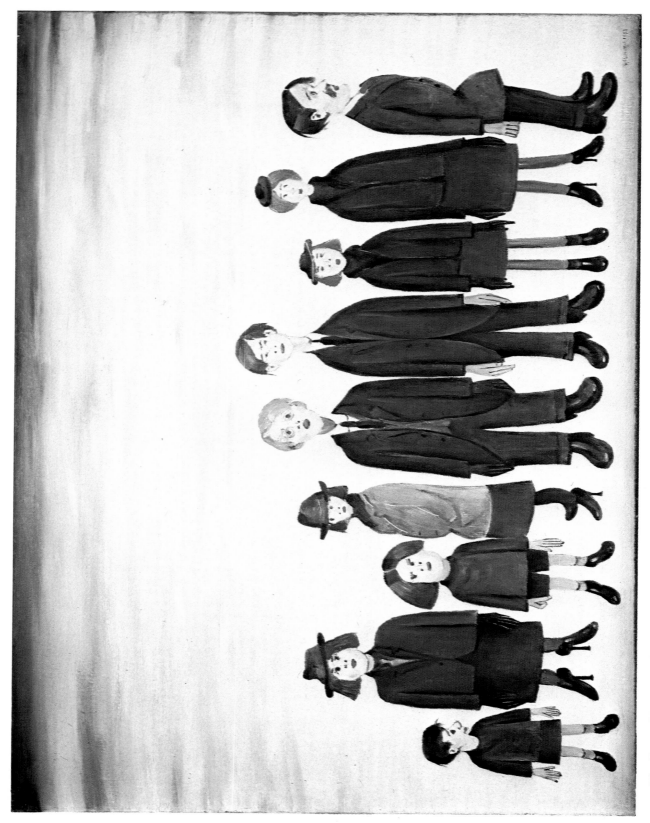

134 The Funeral Party, 1953. Oil on canvas

22

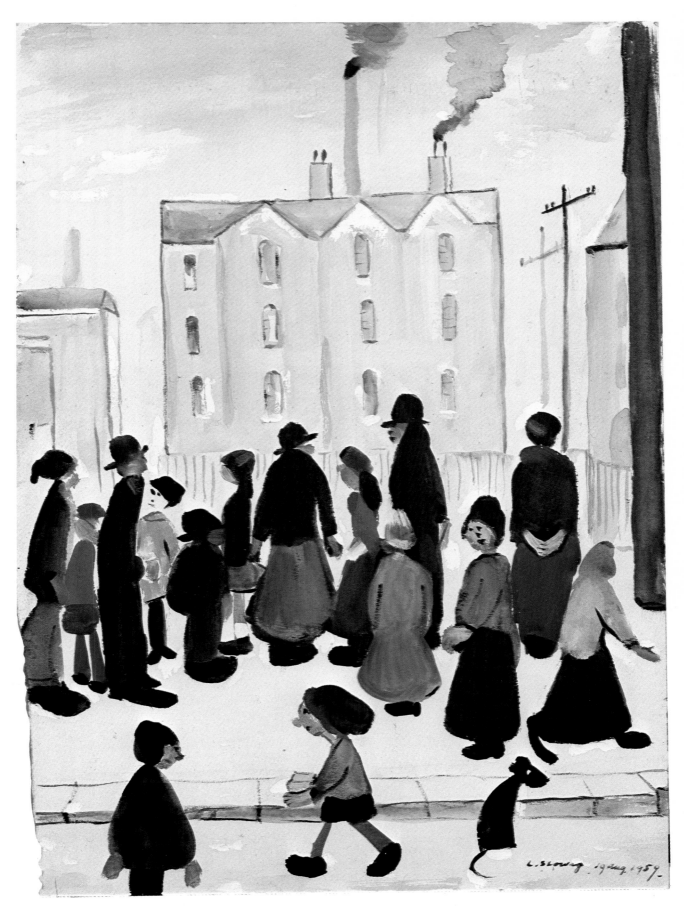

150 Group of People, 1959. Watercolour

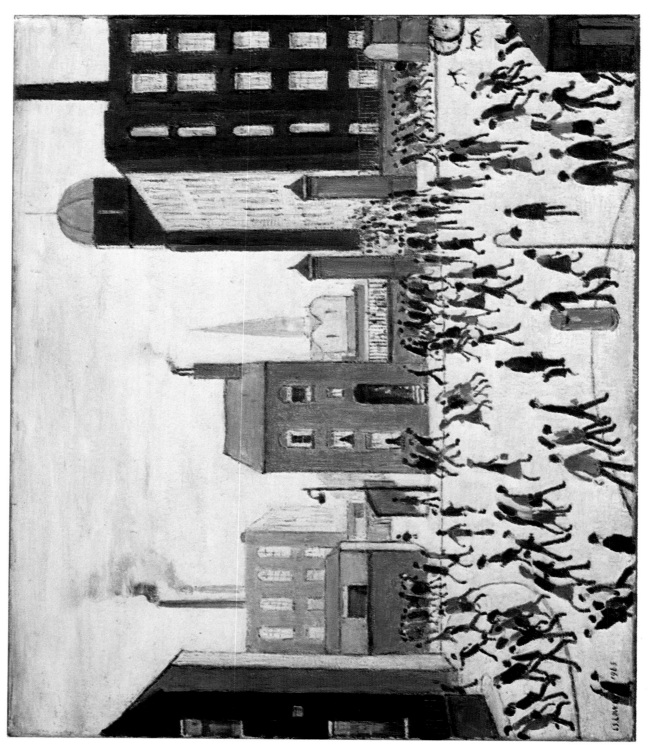

152 Mill Scene, 1965. Oil on canvas

L. S. LOWRY: the man

Laurence Stephen Lowry has been variously described as being lonely, solitary, enigmatic and eccentric without any definition of these terms in relation to the man. In some degree these attributes could be applied to certain aspects of his long life and some refer more strongly to different periods. The actions of most people, if viewed through a magnifying lens, could be classified in the same way.

The work of an artist is a solitary occupation but a man is lonely only if he has no friends and no human relationships and desperately wants them. L. S. Lowry had friends and many acquaintances. Some he kept at arm's length and to others he was very close. Above all he was self-sufficient. Such a man has been described as 'the strongest man in the world'.

Some things about Lowry were enigmatic. Who can explain why he kept people he knew almost secret one from the other? Why, about his employment in the business world, was he so secretive? To friends with whom he talked freely about all aspects of his life he never mentioned his occupation outside painting.

L. S. Lowry's paternal grandfather moved from Northern Ireland to Liverpool and then to Manchester. Because of this connection and because he knew little of his forebears L. S. Lowry, when on a visit to Dublin went to Belfast intending to make enquiries about his grandfather's family but, in his own words, said 'I did not like Belfast so I went back to Dublin'.

His father R. Stephen Lowry was born in Manchester and eventually married Elizabeth Hobson whose father was a member of a Manchester firm of hatters. Her upbringing was more cultured than that of her husband. She was an accomplished pianist and had played at the Charles Rowley concerts in Manchester.

For a short period they lived in Liverpool and then returned to Manchester where R. S. Lowry obtained a post with a firm of estate agents. In 1887, 1 November, Laurence Stephen Lowry was born at 8 Barrett Street, Stretford. They next moved to 4 Ellesmere Place, Longsight and then to the rather better class house, 14 Pine Grove, Longsight. About 1895 Laurence began attending Victoria Park School. He claimed that whilst at school he was no good at anything. Games, as far as playing was concerned, had no interest for him and by the time he was fifteen he said he realized that one game was very like another and took no further part.

Until he was fifteen he had not taken any interest in drawing. Then he began to make sketches but as he put it 'I didn't like it much'. As a boy he did 'little drawings' whilst on holiday and some of them he used as subjects for paintings forty years later. At that early time sketching was the occupation of a boy who had few available friends and spent most of his leisure with his parents. Because of his talent there were suggestions that he should attend classes at an art school.

In his childhood days there were never any birthday parties for him. Nor were there any birthday presents. At Christmas he received presents from Father Christmas but he said almost always he saw his father bring them into the bedroom. There were never any Christmas decorations in the house. Sometimes there were visits by a few relations but very little social contact with them. He did, however, maintain contact with an aunt in Cricklewood by making monthly visits until her death. Speaking of his parents he said 'We were a cold lot. We were cold fish.'

His interest in sport in the early part of this century has often been referred to but it was a knowledge from newspapers and other people, allied to a good memory, from which he spoke in later life. He liked to run through the names of the teams in the Northern Union (now Rugby League) teams of the past. That so many had faded away seemed to amuse him. Yet, he insisted that he had seen only one rugby match played at Swinton where the ground was on his doorstep. On that one occasion he said he had no interest in watching the game.

He could speak freely of county cricketers but had been to watch county matches 'very, very rarely'. We found that he had been a patron of the Clifton Cricket Club, just a little way from his Pendlebury home. His explanation was that someone asked him to subscribe and there was no reason not to do so. Sometimes he went to watch their games but it was the walk across 'the Moss' to the ground he enjoyed, not the game. Similarly, although an avowed supporter of the Manchester City Football Club, he did not go to watch. It was an attachment rather than active support. Always he was more interested in football than in cricket but his native loyalty led him to 'support' Lancashire County Cricket Club, Manchester City Football Club and Manchester United Football Club. As an outlet for people's natural aggression he considered sport to be vital.

All his leisure time was spent in painting and drawing, in walking about the area in which he lived, visits to the theatre and going to concerts. In middle life he was interested in the activities of the Un-named Society, Manchester's leading amateur dramatic society, and was invited to design scenery for them but never did so. When we talked to him about writing as a means of expression as well as painting he roared with laughter, saying he just could not write and recounted that when he was invited to write notices of

art exhibitions for the *Manchester Guardian* his mother laughed and said 'Why, the exhibitions would be over before you could write a word'. And he agreed with her.

As a family they attended the Church of England, travelling from Swinton to New Cross, Manchester and as a boy, he attended Sunday School near his home. After his mother's death he gradually left off churchgoing. In later life he said 'I don't have any exceptional religious views but I've a feeling there's something behind it all. What it is I've no idea and no doubt I never will have. Nature never wastes anything. As we are part of Nature it is likely that we will not be wasted when we die. We have no free will. It is because of our make-up, not our environment'. He went on to talk about the trouble taken to create everything in the world – creatures – creatures like ourselves and expressed the view that it would not all be wasted when we die. Asked if he had the opportunity, would he live his life over again? With emphasis he replied 'I would not, thank you. I've had quite enough'.

At his home in Mottram he lived, apart from his sparsely furnished bedroom and his studio, in one room. It was over-full with heavy furniture inherited from his parents. Placed on the surfaces were many objects he had acquired, mainly as gifts and the clocks, some of them superb pieces which he had inherited from his mother. She had received them from her mother who was the collector. There was a display cabinet tucked away in a corner, full of his mother's pottery ware. His comfortable leather armchair was placed in front of an electric fire. With Edwardian graciousness he always insisted on his favoured guest sitting in that chair. Letters he piled, often unopened, in a large porcelain fruit bowl on the table. When they became out-of-hand, they were burned. Asked how it was he always replied to our letters he said 'I open the ones I recognize'.

On the ledge of his mother's upright piano he propped current drawings or recently acquired pictures. Pictures covered the available wall space. There were several Rossettis amongst them. Sometimes one would be replaced by another but his own portraits of his mother and father were permanently in place. Radio was his constant companion when alone – he said he kept it switched on even for programmes he did not like – but the music he really enjoyed.

Music to him was as important as painting. In the middle years he revelled in the music of Beethoven and Mozart but this was gradually replaced by the music of Donizetti and Bellini. The operas of Bellini especially thrilled him, *Norma* being his favourite, which he frequently heard from records. On his 77th birthday the Hallé Orchestra gave a concert in his honour. He had been consulted about the programme. Beethoven, Mozart and Brahms had been included and he asked for some Bellini but this was not possible. As we walked into the Free Trade Hall he mischievously said 'You and I are going to enjoy the Bellini tonight'. Hindemith's *Mathis der Mahler* had been chosen as specially appropriate by the programme planners. Afterwards, Mr. Lowry said he didn't enjoy the piece but added that it was so powerful the other items seemed pale, 'the impact on you is so great you can't forget it, even if you don't like it'.

It was noticeable that everyone who knew him referred to him as 'Mister Lowry'. Within his family and by friends of the earlier years he was addressed as Laurence. In talking to him about this the suggested explanation was in part, that he himself never addressed anyone by the forename. He agreed and added that although he would, with some people, like to use their first names 'I have never been able to bring myself to do it'.

There was a natural reserve about him but woe betide anyone who tried to take him in or especially those who pretended to knowledge they did not possess. He hated pretence and insincerity. He sensed at once the insincerity of those, and they were many, who approached him and by using flattery hoped to obtain a picture or even to buy one cheaply. No amount of money or persuasion would obtain one.

Conversely, he could be generous, indeed he was a generous man, helping many art students with their work, buying pictures at exhibitions to help younger artists, and on one occasion he was visited by a young girl who arrived without appointment. She said she would like to buy a picture and had saved £25 to buy one. This when his drawings were priced in hundreds of pounds. He was so impressed that he let her have a painting for the £25. The next day her mother returned with the picture, full of apologies. He reassured her, told her it was all right, the little girl could have it.

Similarly, unannounced, a rather down at heel man called at his house saying he had for a long time wanted a Lowry picture but could not possibly afford one. At last he had bought one at a very low price he could just manage from a second-hand shop. He showed it proudly to Lowry, pointed out that it wasn't signed and asked him with some diffidence to add his signature. Mr. Lowry told us that it was not one of his drawings. 'I had not done it' he said. 'What did you do?' we asked. 'Why, I signed it. What else could I do? I couldn't disappoint the poor man.' He pointed out to us that it was the only time he had done so and would not have signed it under any other circumstances. But the lady who called on him to inform him that she had bought one of his drawings

was to receive different treatment. Non-plussed by her remark he remarked 'That is very nice'. She produced the drawing which he recognized. He told her the subject was a farm at Clifton. She continued by saying her friends had told her his pictures were more valuable if they had figures on them and thereupon asked him to put a few on for her. He replied 'I can't do that, madam. I've had trouble with my trades union for doing things like that' and sent her on her way.

It is difficult to summarize Lowry, the man, but he was a 'Manchester Man' in the true liberal tradition of the *Manchester Guardian*, Miss Horniman's Repertory Theatre and the Manchester playwrights, Brighouse and Houghton, the Hallé concerts and the splendid Victorian buildings of the city.

Neither his parents nor he were interested in politics in an active way. In the last twenty years he had Conservative leanings but in 1966 he considered that only Harold Wilson was able to lead the country.

His father did not drink anything alcoholic, explaining to his son that he was afraid he might get a liking for it. L. S. Lowry never drank alcohol, following his father's advice. Until he was twenty-three he smoked cigarettes but caused a fire when smoking in bed. This so upset his mother that he gave up smoking completely.

He was a big man, over six feet tall, large of frame but in no sense over-weight, pink complexioned, grey hair cut short and usually a little ruffled, and with quick-seeing grey-blue eyes behind his gold rimmed spectacles. A commanding figure. As a young man he was thin with a somewhat gaunt look which made him a conspicuous figure as he strode, carrying a walking stick, about the Irwell valley and the mossland paths near his home in Pendlebury. Frequently he was alone but sometimes accompanied by an artist friend, Edward Kent.

A most unexpected aspect of the man was that he loved children and had always done so. He admired their frankness, respected their opinions, valued their freshness of vision and was protective towards them.

He had an engaging sense of humour and relished jokes that poked at Authority and the Establishment. Paradox seemed to appeal to him. 'It takes a lot of rest to make me tired' was one of his remarks. In a rather grand restaurant something was being prepared over a spirit stove on a trolley by the table. He commented to a friend 'In a place like this you would think they could afford a kitchen'.

He found little to please him about life in the last twenty years. The phrase 'Everything improves worse' coined by a friend, delighted him. He referred to it frequently saying it expressed his own view of the world today.

L. S. LOWRY: the artist

When Laurence Stephen Lowry began painting what has become known as the industrial scene, that is, pictures of the industrial North with its forests of chimneys, cliff-faced brick factories, curves of viaducts, jig-saws of houses and its people it was not because of any nostalgia but because it was the reality he knew. It was this type of picture for which he became known and which is still the most popular up to the present. But Lowry was, during the same period painting other subjects; seascapes, lyrical landscapes and groups of people which in the end took over from the major corpus of his most familiar work.

There was nothing spectacular about his beginnings as a artist. No brilliant talent was noticeable in the young boy. No leaning towards art set him on course to achieve the description 'one of the most original English painters of this century' as he eventually did. There was no hint that he would become perhaps Lancashire's greatest artist and certainly one of the most loved of British painters.

When he was about fifteen he began to make sketches as a pastime during his holidays, always with his parents, at Lytham, Colwyn Bay and Rhyl. Drawing gave him no special pleasure at that time but he had a certain facility which made him continue doing 'bits of things' when at home. This ability led to suggestions that he should take lessons, so, according to the artist, he began attending Manchester Municipal School of Art as an evening student in the year 1905 or 1906. Freehand drawing, preparatory antique and figure drawing were his subjects under Miss Lake and Miss Bradbury and later, antique under Adolphe Valette.

Valette, a French artist, had taken a post with Norbury Natzio Co., Lithographic Printers, in Manchester. In the evening, to keep in touch, he attended evening classes at the School of Art where the principal quickly recognized his quality and invited him to become a tutor, which he did in 1906. Valette later was in charge of the life-drawing class and it is clear that he had a real influence on Lowry. Valette was a painter of distinction, bringing a glimpse of painting in the French Impressionist style to Manchester. Lowry said that Valette had been influenced by the work of Guillaumin.

At this time Miss Lake taught painting and Henry Cadness design, but Lowry did not attend these classes. He spoke to Valette about the possibility of having lessons in painting from him but Valette refused, saying 'you cannot teach anyone to paint', but did suggest that Lowry might go to Willy Fitz for a grounding in painting. Fitz, a German, had a small studio in Alexandra Road and there Lowry went

irregularly. He described Fitz as a rather rough, brusque man but from him he learned 'the German solidity, mass and weight'. Also he had a few lessons in portrait painting from Mr. Barber in his Brown Street studio. Otherwise, Lowry said, he never really had any lessons in painting, that he taught himself and certainly never had any painting lessons at the School of Art.

There he concentrated on drawing and throughout his life insisted that drawing was the basis of painting. He regretted that the subject was now neglected in some art schools. He considered that the only classes worth while were life-drawing classes and quoted Valette 'If you can draw life you can draw anything' and Dodds, also in charge of a life-drawing class at the Manchester School of Art, who said 'From life you can draw badly well'.

But Valette encouraged Lowry to paint, telling him to bring his paintings for him to see, which he did but they were never criticized, Valette usually saying 'It is coming on nicely' thus encouraging him. On one occasion Lowry was talking about giving up painting. Unknown to him Valette went to see Lowry's father to ask him to persuade his son to continue his classes as he thought 'he had something in him'.

Later in life Lowry expressed the view that composition and design should not be taught as it anchored the student to tradition and made it more difficult to break away. He once puzzled a friend by saying that drawing from the antique was more difficult than from life. Asked to explain he said 'the antique doesn't move'. This reply was even more puzzling until he added 'If you draw from life, whatever you do, you can say it was like that when I drew it but it moved. You can't say that about the antique'.

Whilst he was attending the art school the family moved in 1909 to Pendlebury, some five miles west of Manchester. Pendlebury was a district of concentrated industry: coal mines and cotton mills. They loomed up from the pavements and in the distance created the distinctive sky-line. Laid out between them were rows of workers' cottages. Investing it all was the richness of working class life. At first Lowry disliked Pendlebury intensely, became used to it, then came not to mind it, then liked it and finally became obsessed by it.

At this time he was constantly looking for subjects and found these within the limits of his home circle, the area where he was living and at the seaside places when on holiday. In his search for subjects he was always observing closely and making sketches of those scenes from which he considered he could make a picture. And that was always, throughout his life, the touchstone of his endeavour, to make a picture. The emotion engendered by a subject rarely, if ever,

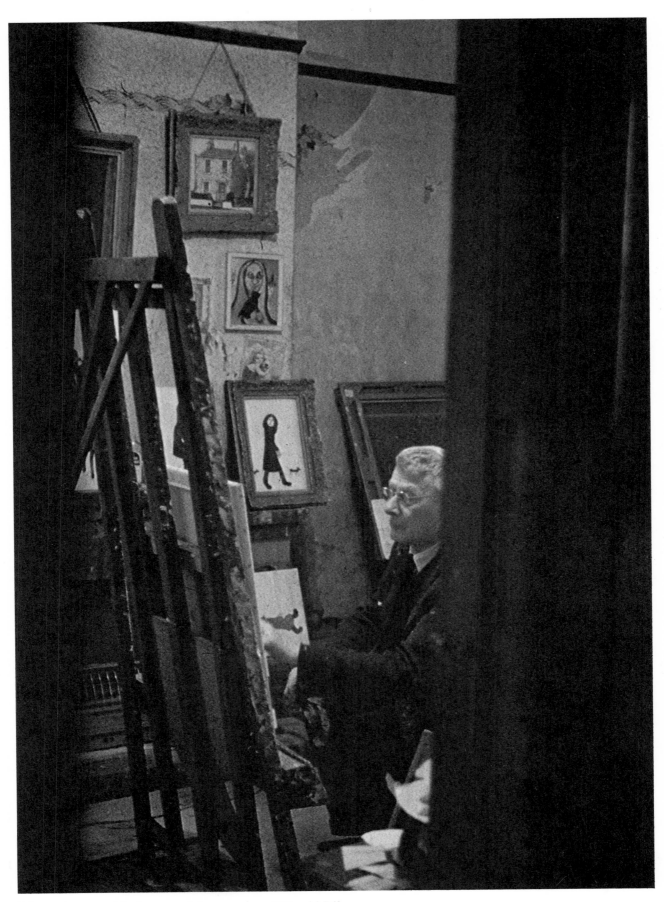

'The artist at work' photograph by courtesy of Harold Riley

urged his choice.

In these formative years he was mainly interested in landscapes and admired the work of J. Buxton Knight. To the west of Pendlebury was an open area of mossland with its scattered farms. To the north was the valley of the River Irwell with some industry dotted about the setting. Here he walked in his leisure time and later worked up pastel drawings and paintings from the sketches he had made. At this time, too, some of his pastel drawings were of Lytham and of the Fylde countryside made from holiday sketches. These have been described as being influenced by the French Impressionists. This Lowry denied as he denied the influence on his paintings in the 1920s. He said he had not seen any French Impressionist paintings at that time apart from the work of Valette.

The technique used in his early pastels was conditioned by the materials. He said anyone doing the same subject and using pastel would have done them in the same way.

By 1915 he began to see the possibilities of industrial buildings and congested streets as subjects. At first these were done in pastel but he soon realised that he could not achieve the required 'weight' in this medium and turned to paint. During these years he frequently walked to Bolton on Saturdays and said that apart from the immediate environment of Pendlebury it was the familiarity with the views along the road, cotton mills beyond cotton mills interspersed with houses, that slowly awakened him to the pictorial possibilities.

In 1921, in the offices of a Manchester architect, Lowry had, with two others, his first real exhibition. The review by Bernard Taylor, the art critic in the *Manchester Guardian*, of his work was favourable but in conversation Mr. Taylor suggested that the pictures were too dark and would be improved by 'lightening' them, pointing out that Lancashire was often in a pearly light which affected the colour of the buildings. Lowry was a little annoyed. He went home and did a painting with a completely white background. On taking it to Mr. Taylor, he unwrapped it and asked with a little pique 'Is this what you meant?' Mr. Taylor looked at it and replied 'Yes, that is much better'. Lowry's reaction, expressed later, was 'I could have killed him'. He came to see that Taylor was right and for some years experimented with the use of flake white paint to achieve the various qualities he required. He varied the number of white layers in preparing the canvases for different subjects, the thickness of paint surrounding the figures and buildings and above all he gained the knowledge of how white paint would mature over the years.

Also, having absorbed the industrial scene, he could not find that any artist had previously used that subject as an inspiration for his art. As industry developed in the eighteenth and the early nineteenth centuries the newness of the scene suggested subjects to some artists but mainly as records, illustrations for books or as a vehicle for a study in dramatic lighting as in the case of Joseph Wright. Lowry made extensive enquiries to find if the subject had been seriously undertaken not only in Britain but in other countries. Apparently it had not, so he decided, deliberately decided, to pursue this new direction in painting and to succeed.

Slowly the vision, the idea, and the technique fused. He was aware too, that artists sometimes achieve greatness by being the first to say something new in a new way. In his early drawings the people inhabiting his streets were very carefully and accurately drawn. As he progressed he found that trying to paint them in large numbers was time consuming, tedious and difficult: nor had they the feeling of movement he required. From 1925 the figures changed, becoming more impressionistic. They were somewhat stiff at first but by 1930 they had become more fluid and alive. These were the figures which were so wrongly referred to as match-stick people. He was aware that he had lost something of their static quality but had gained also, for he found that figures gave life to a picture and were necessary because his pictures were as much about people as where they lived, how they lived, where they worked and where they enjoyed themselves.

It has been remarked that Lowry was not a 'colourist'. Certainly he did not use bright colours but he would have done so if he had been painting in the South of France. The North's muted tones did not demand it but he had a great feeling for the colours he needed and deliberately chose to use. From flake white, yellow ochre, Prussian blue, ivory black and scarlet vermilion he achieved a whole range of subtle tones and in his own words he said 'I wouldn't mind putting on a bit of scarlet vermilion if the picture needed it: slap it on out of the tube even, but it's very expensive so naturally I'm very careful with it'. And he used a penknife to incise lines and to scrape away paint for purposes of perspective. A few years ago an eminent artist said 'No one living can teach Mr. Lowry anything about painting. He knows it all'. Indeed, whilst the paintings seemed so simple they are so technically complex that the same artist said 'There will be no passable forgeries of Lowry's paintings – they are too difficult for it to be worth the effort'.

It cannot be emphasized too strongly that always he was concerned with 'making a picture'. To that end he worked sometimes over a period of five years on one painting 'to make it come right'. Many of his paintings are composite and are of no specific place yet they contain elements of something he had previously seen. One, for example, was based on Lincoln but the cathedral was replaced by another

building which he explained by saying 'The artist can see things the camera can't see'. That there are no shadows in Lowry pictures is part of this process. The large numbers of figures, the many horizontal and vertical lines and areas make it compositionally necessary to omit the shadows. But the effect of the light, and in consequence the effect of the shadow, is implied by the tone values. Very early he decided not to use conventional shadows. The problem is rather different in the later figure groups. Here he worked to make the figures 'come forward' and found that shadows assisted the opposite effect so he did not use them.

Throughout the period he was painting the industrial scene he painted, on occasion, other subjects such as the wonderful white seascapes and the rolling landscapes based on the Pennine moorlands. These he said were done 'to let off steam' but they were painted with the same mastery.

When he retired from business life at the age of sixty-five he had already produced a very large number of paintings and drawings mainly done in the evenings, but he had found time to visit many places in this country. He never journeyed to a town expressly to seek subjects but naturally some appealed to him and pictures resulted. His practice was to travel by tramcar, bus or train to some place and wander around for a day or two, seeing and experiencing. After retirement he extended the distances so that by 1965 he could say he had visited every major town in Britain and some in Ireland. He had made drawings from Lands End to John O'Groats. Strangely, London did not interest him pictorially. From his many visits there he produced only one painting and three drawings.

After 1952 he began to visit the North East and to stay near Sunderland for periods. At the same time the impetus to paint industrial subjects lessened. He said he felt he had done it successfully and besides, the whole ethos of the towns had changed with the post-war reconstruction schemes and the changes in society. There could not be a sudden end to these pictures but they became fewer.

He began a new phase: the paintings of people as single figures and in small groups. They were often of strange characters, the deformed, the unusual and people in peculiar situations, all painted on white backgrounds. At first no one was interested in them and he thought he was wasting his time. Eventually interest was shown and Lowry's paintings of people developed with their subtle shadings and the impasto of paint to give them dimension. No matter how odd the people there was no ridicule in his depiction of them. Sometimes the humour of the situation is intentionally expressed – he had a real sense of humour. But he had seen all these people, all the

incidents and had the capacity to remember them years later and to translate them into pictures. Some had an allegorical quality.

Always he had been fond of the sea and his visits to the North East coast gave him the opportunity to do more and more sea paintings which were treated more expressionistically; tankers coming into harbour, the violence of the sea – he thought the sea was a terrible thing – and ships stationary in the distance, all presented him with new problems of expression.

He continued painting and drawing almost to the end of his life though, of course, they became fewer and fewer; but he had not been able to resist painting teenagers in jeans and mini-skirts because, as he said 'I saw them so you can't help it can you?'

As a young man he did not receive much encouragement to continue and on several occasions was on the point of giving up. His father's friends tried to persuade him to enter a more lucrative business. His relations thought his painting activities were something of a joke. Even his father, when, unexpectedly, he sold a painting and a drawing, said 'We shall have to be careful or this young man will be getting big-headed'. His mother was much more sympathetic and he was very attached to her. The strange painting in the Salford Collection *Head of a Man (with Red Eyes)* (Cat. No.122) was painted when he was staying up through the night with his mother who was ill. Some years ago my wife asked him if it was a self-portrait. He snapped out 'How did you know?' She explained and he told us it was the first time anyone had recognized it. After a time he said it was a self-portrait and came about when he looked into a mirror one morning after several sleepless nights.

Despite his lack of success and despite the attitude of friends he did not give up. As he said, 'I had to paint. I couldn't help it'. Yet he said he never liked it and that he had no affection for any of his paintings, except the portraits of his mother and father and those of Ann, his god-daughter, not because of the painting but because of the subjects. This compulsion to paint was, however, secondary to his love of music and he insisted that music was more necessary to him than painting. At times his depression must have been great, for he confided that he had several times contemplated suicide but had been deterred by thinking how awkward it would be for those who found him, no matter what means he had used.

The real turning point came in 1939 when Mr. McNeil Reid of the Lefevre Gallery in London arranged an exhibition of his work at that gallery. Although recognition did not come overnight the way to success was opened. In that year his painting paid its way for the first time, but not until 1951 did he make a profit: the sum of £26.5.0. Some of his pictures

could appear to be Surrealist but their genesis seems to be more practical. *The Same Woman Coming Back* (Plate 20, *L. S. Lowry*, Mervyn Levy, 1961) with its two figures, a woman walking away and by her side the same woman walking forward originated by him painting the back view of a woman. At the time a young girl was present and he asked what they could do with it. She suggested that he paint the same woman looking the other way, which he did, and together they decided on the present title. Similarly, the dream-like landscape *The Lakes* (Plate 15, *L. S. Lowry*, M. Levy, 1961) was the outcome of seeing the reservoirs at Woodhead in the deep dusk when the hills were in dark shadow and the last light gave a whiteness to the water. It did not come from his imagination.

It was clear that he had a great admiration for the Pre-Raphaelite painters, speaking highly of Hughes, as well as the better known. Rossetti was his favourite of the Brotherhood but he considered that Ford Madox Brown was probably England's greatest painter. He owned one drawing by Madox Brown, *Moses and the Brazen Serpent*, but explained he had only the one because they were difficult to obtain. He acquired fifteen Rossetti paintings and drawings in the years when he was financially able to do so, because he admired the artist's skill rather than because they were portraits of women. Women as such had never had any interest in him, he said, nor had he in them.

The Victorian painters he held in high esteem, Frith, Richmond, Etty, Egg and Lord Leighton were frequently in his conversations and he praised 'their tremendous ability'. Of the French Impressionists he said 'I do not much care for them'. In his early days he could not have seen the work of Edvard Munch but later he said it was with Munch that he felt a kinship. If there are other kinships they are with some of the Germans of the period. He mentioned Nolde and Ernst.

Other painters whose work he liked were Dali, for his composition and skill with paint, Magritte 'for everything', Paul Delvaux, Ginner and Sir Alfred Munnings. Munnings he said was a better painter of horses than Stubbs – the skill with which he obtained the sheen of the horses and the feeling of movement were, in his view, unsurpassed. At the Royal Academy Lowry once said to Munnings, 'I must congratulate you on your pictures. I admire them immensely'. Munnings replied, 'I wish I could say the same about yours but I dislike them intensely'.

Already it will be clear that, from the first, Lowry had a real love of pencil drawing, and he was involved in drawing, all his life. From the first conventional line drawings he gained, as time went on, confidence and control of line and developed a technique of producing a rich, even lush line, a delicate silvery line, a use of space and tones values which make them paintings in pencil. This was achieved by using a 5B or 6B pencil, an HB pencil, an eraser and his thumb and finger tips. The rubber was not for correcting mistakes but for erasing, in varying degree, the lines drawn with the soft pencil and re-drawing them, erasing them again and going over them with the HB pencil until the effect he wanted was obtained. He shaded areas, erased them and re-shaded and smudged with complete control, using his finger tip.

Later his drawings were accomplished with greater economy of line and some were less formally structured but conveyed, by impression, the feeling he wanted to capture. Later still some of his figures in pencil became solid black on the white paper in contrast to the outline figures in the same drawing. Lowry's art cannot be considered without placing the paintings and drawings in close parallel. It will then be realised that some paintings are drawings in paint and some drawings are paintings in pencil.

He denied that any of his work was done as a social comment but some, from their very subject had a social connotation; for example, *A Doctor's Waiting Room* (Cat. No.52) and *Laying a Foundation Stone* (City Art Gallery, Manchester). His pictures of the down-and-outs were not done to draw attention to their plight. Whilst he was sorry for them he said 'nothing can be done about it, they are part of life' and he thought they might be happier than he was.

As an artist he is impossible to categorize and pigeon-hole as we so like to do with artists. It is sufficient to say he is one of England's great artists. There had not been his like before, as in the case of Blake. At no time did he compromise his artistic integrity. He achieved, from his depth of vision and by his power of communication the realization that people and places were as he painted them. What he did was to rearrange reality and in so doing reality was revealed.

On his death in February, 1976, following an attack of pneumonia (he was noticeably failing two months earlier) one naturally thought of an epitaph. He himself had suggested 'Those who knew him thought little of him. Those who did not know him thought less'. This joke was unwittingly an expression of his own humility. More fitting as an epitaph was another remark he made 'I did every picture as well as I could'. That is true.

The Salford Collection

Mr. Lowry was a visitor to Salford Art Gallery as long ago as the 1920s, when he must have spent many hours sketching in the surroundings of the Gallery in Peel Park. He would most certainly have visited the Art Gallery during the summer of 1928 when there was an exhibition of oil paintings by William Fitz, an artist who had been his private art tutor during his formative years some two decades earlier.

It isn't perhaps generally realized that L. S. Lowry was appreciated as an artist as early as the 1930s. Records, however, show that he exhibited a painting *Excavations at Manchester* in a 'Summer Exhibition of Recent Paintings by Eminent British Artists', held at Salford Art Gallery in 1934. His name also figured in a similar exhibition held in 1935 and his paintings hung side by side with works by Lucien Pissarro, Stanley Spencer, Sir John Lavery and Richard Sickert. He continued to exhibit pictures at Salford throughout the 1940s and 1950s in such exhibitions as the 'Royal Academy United Artists exhibition', 'British Painting Today' and the 'Society of Modern Painters, Manchester'.

The first picture by L. S. Lowry to be acquired by Salford Art Gallery was the oil painting *A Street Scene – St. Simon's Church* painted in 1928 and purchased for the sum of £20, in March 1936, from the Spring Exhibition of the Manchester Academy of Fine Arts. This purchase was followed by another one in 1939 when *The Lake*, painted in 1937, was bought from Messrs. Alex Reid and Lefevre Ltd, London.

It is obvious from these two purchases that the then Director of the Art Gallery, the late Mr. A. J. M. Maltby (1926–46), was attracted by Lowry's work and this can be shown in a report made by him to his committee in September 1941. The report was as follows: 'Whilst the Chairman of the Art Galleries Sub-Committee (Alderman A. Williamson) and I were in London recently for the purpose of inspecting pictures offered as gifts to this committee, our attention was drawn to a collection of paintings and drawings by L. S. Lowry, a local artist who received his training at the Salford School of Art. Mr. Lowry has achieved considerable fame by reason of his original and unusual method of portraying every day life in Lancashire. His pictures have been purchased for the Tate Gallery and by the Corporations of Manchester, Liverpool and elsewhere. Recently Mr. Lowry had an exhibition of his work in London where he sold a large number of paintings to private collectors. In view of Mr. Lowry's local connection the Chairman and I were of the opinion that an exhibition of Lowry's work would be a feature in our Gallery and we accordingly made arrangements for a show to be held in Salford towards the end of September.'

This exhibition opened on October 1, 1941, and Salford Art Gallery purchased the well known oil painting *Coming from the Mill*. Soon after the exhibition in January, 1942, the artist presented the Gallery with his oil painting *Market Scene, Northern Town* in appreciation of the Committee's invitation to him to hold an exhibition of his paintings in the Art Gallery. This started the long and close association between Salford Art Gallery and Mr. Lowry which lasted until his death in 1976.

Between 1941 and 1959 Mr. Lowry presented twenty-four pencil drawings to the Gallery and the collection was further increased by the purchase of two oil paintings and fourteen drawings from the artist.

In July 1959, the late Mr. A. Frape, the director of Salford Art Galleries and Museums (1946–63), reported to the Art Galleries and Museums Committee that at that time there were in the possession of the Corporation six oil paintings and forty-four drawings by L. S. Lowry, and that he had been informed by the agent of Mr. Lowry that several other pictures were for sale. He reported that, in his opinion, the time was opportune for other oil paintings and drawings to be purchased. As a result of this report the Corporation made £2,000 available for the purchase of nineteen oil paintings and nine drawings from Alex Reid and Lefevre Ltd, London. This purchase included many of the major works now in the Salford Collection such as *The Cripples*, *The Funeral Party*, *Head of a Man*, *House on the Moor*, etc.

Between the years 1959 and 1974 the collection grew steadily, again due to the generosity of Mr. Lowry who donated three oil paintings and ten drawings to Salford, and the collecting policy at Salford Art Gallery from 1936 to 1974 when the collection increased to thirty-two oil paintings, eighty-four drawings and five water colours.

1974 was the year of local government reorganization which amalgamated Salford, Swinton & Pendlebury, Worsley, Eccles and Irlam to form the new city of Salford. Both Eccles and Swinton had maintained close connections with Mr. Lowry and had the foresight to collect examples of his work. The Swinton Collection consists of six oils and twenty-one drawings whilst the Eccles Collection comprises an oil painting and two pencil drawings. The three collections are now jointly referred to as the Salford Collection and form a comprehensive group of forty-three oil paintings, 113 drawings and five watercolours.

The variety and extent of the collection, which dates from 1906–67, makes it possible to trace the artist's development and change of style over the whole of his long and active painting career. It highlights his keen

perception of human behaviour and shows that although he possessed the desire to record people in his paintings he had no wish to pursue the art of portraiture. The portrayal of human activity dominated his work throughout his life, and his carefully drawn groups of people of the early years (No. 54 *On the Sands*) gradually evolved into the crowds of his Industrial landscapes at the peak of his career and reappeared as single figures in the latter part of his life (No. 154 *Gentleman Looking at Something*). Although his observations of society in urban areas often reflected the hard times of the 1920s and 1930s his irrepressible sense of humour resulted in a series of pictures which gently made fun out of otherwise pathetic situations (No. 117 *A Fight*, No. 134 *The Funeral Party*, No. 147 *Man Lying on a Wall*).

Not all the artist's work depicts townscape and people. The appeal of the seaside and coastal scenes attracted his attention regularly (No. 51 *Yachts*,

No. 161 *Waiting for the Tide*, No. 143 *The Estuary*) and during his travels throughout the British Isles he depicted many rural scenes. He was particularly fond of the Fylde landscape of Lancashire and for a period of about seven years he painted in this area to produce a particularly characteristic group of pictures (No. 42 *A Fylde Farm*, No. 56 *Regent Street Lytham*). From time to time throughout his life he needed to escape from the crowds and city life, and these periods of solitude are recorded in his empty seascapes and 'lonely' landscapes (No. 133 and Nos. 119, 130, 131, 132).

At the same time that Mr. Lowry was perfecting his own unique style he was busy recording the disappearing local scene and Salford is indeed fortunate in having many drawings by this artist of the old Swinton, Eccles and Salford areas which are as valuable to the local historian as to the connoisseur of art.

The Salford Collection

Notes to the Catalogue

The Catalogue is arranged in chronological order of the artist's works. Where the work is undated it is marked *Circa* on the most reliable information available. The dimensions are given in centimetres (2·54 cm approximate to one inch) and height precedes width. The method of acquisition is followed by the gallery's accession number for the work.

Exhibitions
The Salford Collection has been regularly used in exhibitions throughout Britain. The major exhibitions in which a work has been hung are listed in chronological order throughout the catalogue.

Belfast 1951
Ulster Museum. January–February.

Wakefield 1955
Joint exhibition at the Art Gallery. 6 May–11 June.

Manchester 1959
City Art Gallery. 3 June–12 July.

Harrogate 1960
Harrogate Festival of the Visual Arts. 6–13 August.

Sheffield 1962
Graves Art Gallery. 15–28 September.

Arts Council 1966
Touring exhibition visited Sunderland Art Gallery, Whitworth Art Gallery (Manchester), Bristol Art Gallery and the Tate Gallery (London) from 27 August, 1966 to 15 January, 1967.

Nottingham 1967
Nottingham Playhouse. 6–28 February.

Crane Kalman Gallery 1968
The Loneliness in L. S. Lowry, held at the London gallery from 7–30 November.

Arts Council 1970
Decade 1920–1930 toured art galleries at Leicester, Newcastle, Doncaster, Manchester, Bristol and London from 21 February to 30 August.

Norwich 1970
Castle Museum, Norwich. 14–24 October.

Belfast 1971
Arts Council of Northern Ireland exhibition at the Ulster Museum. 5–22 May.

Liverpool 1973
Walker Art Gallery. 1 May–1 June.

Nottingham 1974
Nottingham University Art Gallery. 28 May–15 June.

Royal Academy 1976
Retrospective Exhibition. 4 September–14 November.

Pictures from the Salford Collection have also been loaned to exhibitions at Ilkley, Halifax, Eccles, Swinton, Pendlebury, Bury, Altrincham, Stalybridge, Kendal, Accrington, the Wellcome Institute of Medicine, London, Mottram-in-Longdendale and Wigan.

Illustrations
A number of books, several catalogues and many articles have been produced on the work of L. S. Lowry. Most have been illustrated in part with pictures from the Salford Collection.

Reference is made to illustrations in the following books and catalogues:

The Drawings of L. S. Lowry
With an Introduction and notes by Mervyn Levy. Published by Jupiter Books, 1963. Reprinted 1973.

The Paintings of L. S. Lowry
With an Introduction and notes by Mervyn Levy. Published by Jupiter Books, 1975.

Royal Academy catalogue
L. S. Lowry 1887–1976. Published by the Royal Academy of Arts, 1976.

The Drawings of L. S. Lowry Public and Private
With an Introduction and notes by Mervyn Levy. Published by Jupiter Books, 1976.

Other books on L. S. Lowry:

The Drawings of L. S. Lowry
By Maurice Collis. Published by Alex Reid & Lefevre Ltd., London, 1951.

L. S. Lowry
By Mervyn Levy. *Painters of Today* series. Published by Studio Books, London, 1961.

Local Collection
Salford City Art Gallery and Salford City Libraries have additional material on L. S. Lowry, including books, catalogues, illustrations, films, periodical articles and newspaper reports.

Copyright

1 Nude Boy Seated

1906
Pencil. 37·8 × 56·2 cm
Signed: L. S. Lowry 1906
Purchased from the artist (1961–12)
Illus: *Drawings of L. S. Lowry – Public and Private*

The Salford Collection contains a number of art school studies executed at the Manchester and Salford Schools of Art from 1905/6 to 1925.

2 Still Life

1906
Oil on canvas board. 23·5 × 33·5 cm
Unsigned
Purchased (1959–629)
Exhib: Manchester 1959, Harrogate 1960, Arts Council 1966, Nottingham 1967, Liverpool 1973, Royal Academy 1976

The Art Gallery has a note stating that this painting was probably painted at a time when the artist was attending a private class with Mr William Fitz, a teacher of reputation then living in Moss Side, Manchester.

3 Reclining Nude

c.1906
Pencil. 35·1 × 52·8 cm
Signed: L. S. Lowry
Purchased from the artist (1961–11)
Illus: *Drawings of L. S. Lowry – Public and Private* (dated as c.1906)

Art school study.

4 Female Nude (Seated Woman with a Book)

c.1906
Pencil. 53·8 × 36·3 cm
Signed: L. S. Lowry
Presented by the artist (F107–1975)
Illus: *Drawings of L. S. Lowry – Public and Private* (dated as c.1906)

Art school study.

5 Study of Head from the Antique

c.1907
Pencil. 41·0 × 34·5 cm
Signed: L. S. Lowry
Purchased from the artist (1961–8)
Illus: *Drawings of L. S. Lowry – Public and Private* (dated as c.1907)

Art school study.

6 Study of Two Hands

c.1907
Pencil. 41·0 × 34·5 cm
Unsigned
Purchased from the artist (1961–8)

Art school study. On the reverse of 'Study of Head from the Antique' (No.5).

7 Portrait of a Man

1908
Pencil. 40·2 × 27·7 cm
Signed: L. S. Lowry 1908
Presented by the artist (1952–51)
Exhib: Manchester 1959, Harrogate 1960, Arts Council 1966, Nottingham 1967, Royal Academy 1976
Illus: *Drawings of L. S. Lowry – Public and Private*

Art school study.

8 Near Blackpool: an original drawing

1908
Pencil. 11·5 × 18·4 cm
Signed: L. S. Lowry 17/5/08 Near Blackpool: an original drawing
Purchased (F7-1976)

Entry in an autograph album owned by a lady who attended the same school as the artist.

9 Head from the Antique

c.1908
Pencil. 52·0 × 33·7 cm
Signed: L. S. Lowry 10 hrs.
Purchased from the artist (1961–7)
Exhib: Royal Academy 1976
Illus: *Drawings of L. S. Lowry – Public and Private* (dated c.1908)

Art school study.

10 Seated Nude (facing left)

c.1908
Pencil. 53·0 × 34·5 cm
Signed: L. S. Lowry
Purchased from the artist (1961–13)
Exhib: Arts Council 1966
Illus: *Drawings of L. S. Lowry – Public and Private*
(dated as c.1908)

Art school study.

11 Discus Thrower

c.1908
Pencil. 26·0 × 34·2 cm
Unsigned
Swinton Collection

Art school study. On reverse of 'Rear of
Property on Bolton Road, Pendlebury' (No.116)

12 Arden's Farm, Swinton

1908–9
Oil on board. 17·5 × 25·5 cm
Unsigned
Presented by the artist (1974–79)
Swinton Collection
Exhib: Royal Academy 1976

13 Clifton Junction – Morning

1910
Oil on board. 20·2 × 34·8 cm
Signed: L. S. Lowry 1910
Presented by the artist (1974–77)
Swinton Collection

This, and the following picture, constitute a pair
painted on the same day. They are virtually the
last pictures painted outdoors by Mr Lowry.

14 Clifton Junction – Evening

1910
Oil on board. 19·0 × 35·5 cm
Signed: L. S. Lowry 1910
Presented by the artist (1974–80)
Swinton Collection
Exhib: Royal Academy 1976

See No.13.

15 Portrait of the Artist's Father *Colour Plate*

1910
Oil on canvas. 41·0 × 31·0 cm
Signed: L. S. Lowry 1910
Lowry bequest (F9–1976)
Exhib: Royal Academy 1976
Illus: *Royal Academy Catalogue*
Paintings of L. S. Lowry

Mr Lowry bequeathed this painting, together
with 'Portrait of the Artist's Mother' (No.18)
and two other pictures. The bequest was made
many years ago and, whilst the artist allowed the
gallery to display the other pictures, he retained
the two portraits until his death.

16 Male Nude from the Antique

c.1911
Pencil. 52·2 × 35·0 cm
Unsigned
Purchased from the artist (1961–96)

Art school study.

17 Male Nude from the Antique

c.1911
Pencil. 54·2 × 35·0 cm
Signed: L. S. Lowry
Purchased from the artist (1961–9a)
Exhib: Nottingham 1967
Illus: *Drawings of L. S. Lowry – Public and Private*
(dated as c.1911)

Art school study.

18 Portrait of the Artist's Mother *Colour Plate*

1912
Oil on canvas. 46·1 × 35·9 cm
Signed: L. S. Lowry 1912
Lowry bequest (F10–1976)
Exhib: Royal Academy 1976
Illus: *Royal Academy Catalogue*
Paintings of L. S. Lowry

Restoration work on this painting prior to the
Royal Academy exhibition revealed evidence of
three other pictures beneath the portrait, each
covered with a layer of filler (probably lead
white). See No.15.

19 Landscape

1912
Oil on canvas. 33·5 × 23·5 cm
Unsigned
Purchased (1959–630)
Exhib: Manchester 1959, Harrogate 1960,
Liverpool 1973
Illus: *Paintings of L. S. Lowry*

Compare 'Country Lane' (No.28).

20 Boy in a School Cap

1912
Pencil and white chalk. 42·5 × 24·5 cm
Signed: L. S. Lowry 1912
Purchased (1959–626)
Exhib: Manchester 1959, Nottingham 1967,
Norwich 1970, Royal Academy 1976
Illus: *Drawings of L. S. Lowry – Public and Private*

See also No.24 – the same boy is sitter.

21 Girl with Bouffant Hair

c.1912
Pencil. 41·8 × 34·8 cm
Signed on reverse: L. S. Lowry
Purchased from the artist (1961–18)
Illus: *Drawings of L. S. Lowry – Public and Private*
(dated as c.1912)

Art school study.

22 Head of a Young Man in Cap

c.1912
Pencil. 45·5 × 33·7 cm
Signed: L. S. Lowry
Purchased from the artist (1961–19)
Exhib: Liverpool 1973
Illus: *Drawings of L. S. Lowry – Public and Private*
(dated as c.1912)

23 St. Mary's Church, Swinton

1913
Pencil. 20·3 × 11·7 cm
Signed: L. S. Lowry 1913 (in ink)
Presented by G. B. Cotton (1974–90)
Swinton Collection
Exhib: Royal Academy 1976
Illus: *Drawings of L. S. Lowry – Public and Private*

24 Portrait of a Boy

c.1913–14
Oil on board. 37·3 × 26·4 cm
Unsigned
Purchased (1959–632)
Exhib: Manchester 1959, Nottingham 1967,
Liverpool 1973
Illus: *Paintings of L. S. Lowry*

See No.20.

25 Head of a Bald Man

c.1913–14
Oil on board. 20·7 × 18·2 cm
Unsigned
Purchased (1959–631)
Exhib: Manchester 1959, Harrogate 1960
Illus: *Paintings of L. S. Lowry*

This full-face impression is one of the earliest of
the imaginary portraits which the artist painted
at different stages of his career. See also No.122.

26 Study of a Woman's Head

1914
Pencil. 44·1 × 35·5 cm
Signed: L. S. Lowry 1914
Presented by the artist (1952–55)
Exhib: Manchester 1959, Sheffield 1962
Illus: *Drawings of L. S. Lowry – Public and Private*

Art school study.

27 Head of a Man

1914
Charcoal and chalk. 45·0 × 32·3 cm
Signed: L. S. L. '14
Purchased (1959–627)
Exhib: Arts Council 1966, Nottingham 1967,
Belfast 1971
Illus: *Drawings of L. S. Lowry*

Art school study.

28 Country Lane (formerly Horse and Cart) *Colour Plate*

1914
Oil on board. 23·6 × 15·6 cm
Signed: L. S. Lowry 1914 (on reverse)
Purchased (F2–1976)
Illus: *Paintings of L. S. Lowry*

See No.19.

29 Female Nude (Nude Girl Holding Apple)

c.1914
Pencil. 54·1 × 36·3 cm
Signed: L. S. Lowry
Purchased from the artist (1961–10)
Illus: *Drawings of L. S. Lowry – Public and Private*
(dated as 1906)

Art school study.

30 Seated Woman

c.1914
Pencil. 51·7 × 33·8 cm
Signed: L. S. Lowry 45 mins.
Purchased from the artist (1961–17)
Illus: *Drawings of L. S. Lowry – Public and Private*

Art school study.

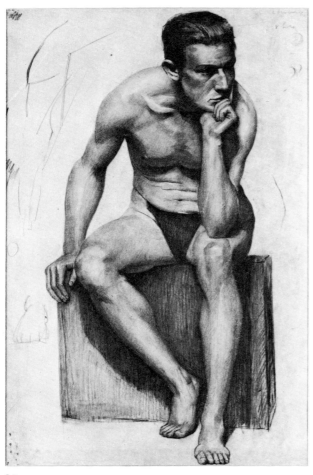

31

31 Seated Male Nude

c.1914
Pencil. 54·8 × 34·9 cm
Signed: L. S. Lowry
Presented by the artist (1952–57)
Exhib: Manchester 1959, Harrogate 1960,
Royal Academy 1976
Illus: *Drawings of L. S. Lowry – Public and Private*

Art school study.

32 Study of a Female Head

c.1914
Pencil. 33·2 × 27·5 cm
Signed: L. S. Lowry (in ink, possibly later)
Presented by the artist (F108–1975)

Art school study.

33 Man Wearing Smock

c.1916
Pencil. 54·0 × 36·0 cm
Signed: L. S. Lowry, 1 hr.
Presented by the artist (F109–1975)
Illus: *Drawings of L. S. Lowry – Public and Private*
(dated as 1916)

Art school study.

34 Head of a Man

1917
Pencil. 44·4 × 35·3 cm
Signed: L S L '17
Presented by the artist (1952–59)
Illus: *Drawings of L. S. Lowry – Public and Private*

Art school study.

35 Head of a Man with Moustache

1917
Pencil. 44·3 × 35·4 cm
Signed: L. S. Lowry 1917
Presented by the artist (1952–60)
Illus: *Drawings of L. S. Lowry – Public and Private*

Art school study.

36 Girl with Necklace

c.1917
Pencil. 52·8 × 34·5 cm
Signed: L. S. Lowry
Purchased from the artist (1961–16)
Illus: *Drawings of L. S. Lowry – Public and Private*
(dated as 1917)

Art school study.

37 Model in Dutch Costume

c.1917
Pencil. 53·0 × 35·5 cm
Signed: L. S. Lowry 1 hr.
Presented by the artist (1952–58)
Illus: *Drawings of L. S. Lowry – Public and Private*
(dated as 1917)

Art school study.

38 Seated Girl in Cap

c.1917
Pencil. 55·6 × 38·2 cm
Signed: L. S. Lowry
Purchased from the artist (1961–14)
Illus: *Drawings of L. S. Lowry – Public and Private*
(dated as 1917)

Art school study.

39 Study of a Girl in Peasant Dress

c.1917
Pencil. 51·0 × 33·8 cm
Signed: L. S. Lowry
Purchased from the artist (1961–15)
Exhib: Liverpool 1973
Illus: *Drawings of L. S. Lowry – Public and Private*
(dated as 1917)

Art school study.

40 Seated Figure (Woman in Indian Costume)

c.1917
Pencil. 37·5 × 28·0 cm
Signed: L. S. Lowry
Acquired from G. B. Cotton (1974–96)
Swinton Collection

Art school study. On reverse of 'Pendlebury Scene' (No.117)

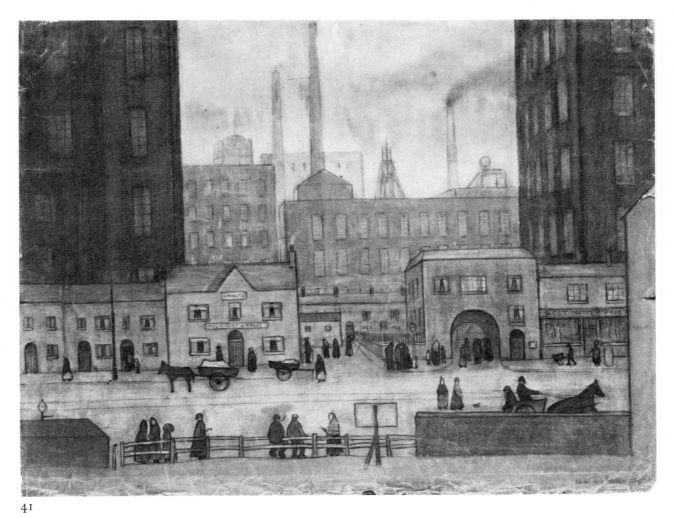

41

41 Coming from the Mill

c.1917–18
Pastel. 43·7 × 56·1 cm
Signed: L. S. Lowry
Presented by the artist (1958–4)
Exhib: Nottingham 1967, Norwich 1970, Belfast 1971, Nottingham 1974, Royal Academy 1976

This composition probably provided the basic pattern for a number of the artist's later mill scenes and industrial landscapes. The oil painting 'Coming from the Mill' 1930 (No.108) is a fairly straightforward stylized interpretation of the drawing whilst other examples showing the theme are 'Northern Hospital' 1926 and 'Coming out of School' 1927 (Nos.67 and 76 in the Royal Academy catalogue).

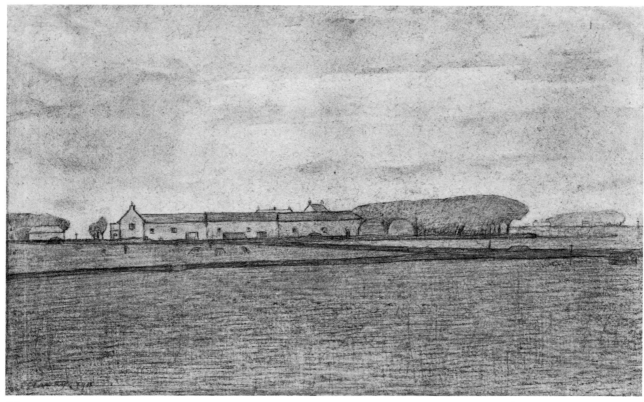

42

42 A Fylde Farm

1918
Wax crayon and pencil. 34·7 × 5·46 cm
Signed: L. S. Lowry 1918
Presented by the artist (1971–24)

In the years 1918 to 1925, the artist produced a
series of landscapes from the Fylde district of
Lancashire. See Nos.56, 72, 73.

43 Model with Head-dress

1918
Pencil. 52·8 × 37·1 cm
Signed: L. S. Lowry 1918
Presented by the artist (1952–56)
Exhib: Harrogate 1960, Royal Academy 1976
Illus: *Drawings of L. S. Lowry – Public and Private*

Art school study.

44 Frank Jopling Fletcher

1919
Oil on canvas. 48·7 × 38·7 cm
Signed: L. S. Lowry 1919
Presented by Philip Fletcher (1965–1)
Exhib: Liverpool 1973
Illus: *Paintings of L. S. Lowry*

Presented by the son of the sitter.

43

45 Peel Park Sketch

1919
Pencil. 19·4 × 10·7 cm
Signed: L. S. Lowry 1919
Presented by the artist (1960–348d)
Exhib: Liverpool 1973
Illus: *Drawings of L. S. Lowry – Public and Private*

Working sketch showing two distant church towers and obelisk in the park. In the period 1919–30, the artist sketched many views in and around Peel Park and sometimes composed paintings of the area. See also Nos.46–9, 60–2, 64, 91, 93, 94–6, 98–100, 114.

46 Peel Park Sketch

1919
Pencil. 19·4 × 10·7 cm
Signed: L. S. Lowry 1919
Presented by the artist (1960–348e)
Exhib: Liverpool 1973
Illus: *Drawings of L. S. Lowry – Public and Private*

Working sketch of view from park with cathedral and chimney in distance. See No.45.

47 Peel Park Sketch

1920
Pencil. 11·4 × 19·0 cm
Signed: L. S. Lowry 1920
Presented by the artist (1960–348a)
Exhib: Liverpool 1973
Illus: *Drawings of L. S. Lowry – Public and Private*

Working sketch of the portico of Lark Hill House with figures. See No.45.

48 Peel Park Sketch

1920
Pencil: 11·4 × 19·0 cm
Signed: L. S. Lowry 1920
Presented by the artist (1960–348b)
Exhib: Liverpool 1973
Illus: *Drawings of L. S. Lowry – Public and Private*

Working sketch showing row of trees with distant view of The Crescent and Art Gallery. See No.45.

49 Peel Park Sketch

1920
Pencil. 11·5 × 19·6 cm
Signed: L. S. Lowry 1920
Presented by the artist (1960–348c)
Exhib: Liverpool 1973
Illus: *Drawings of L. S. Lowry – Public and Private*

Working sketch with bushes, paths and three distant chimneys. See No.45.

50 Wet Earth, Swinton

1920
Pastel. 27·7 × 39·0 cm
Signed: L. S. Lowry 1920
Purchased from the artist (1974–84)
Swinton Collection
Exhib: Royal Academy 1976

See No.70.

51 Yachts *Colour Plate*

1920
Pastel: 28·4 × 38·2 cm
Signed: L. S. Lowry 1920
Purchased (1959–628)
Exhib: Arts Council 1966, Nottingham 1967, Royal Academy 1976

Coastal scenes interested the artist throughout his life. See No.161.

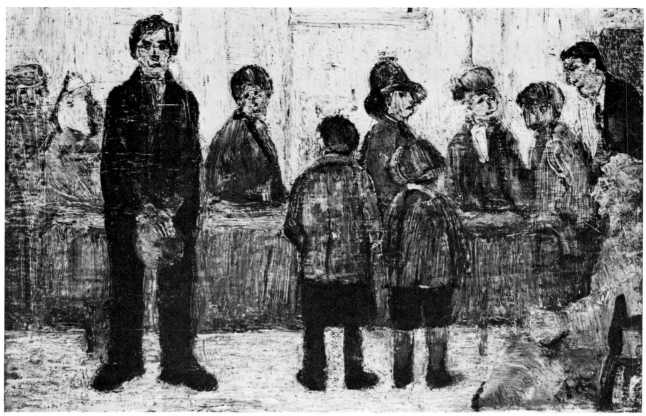

52

52 A Doctor's Waiting Room

*c.*1920
Oil on board. 27·3 × 40·9 cm
Unsigned
Purchased (1959–633)
Exhib: Manchester 1959, Harrogate 1960,
Norwich 1970, Liverpool 1973
Illus: *Paintings of L. S. Lowry*

A possible forerunner to the artist's later figure
groups. See Nos.134 and 135.

53 The Lodging House

1921
Pastel. 50·1 × 32·6 cm
Signed: L. S. Lowry 1921
Presented by G. H. Aldred (1963–44)
Exhib: Nottingham 1967, Norwich 1970,
Liverpool 1973, Royal Academy 1976
Illus: *Royal Academy Catalogue*

It is believed that this may have been the first
picture sold by Mr Lowry from a Manchester
exhibition of 1921.

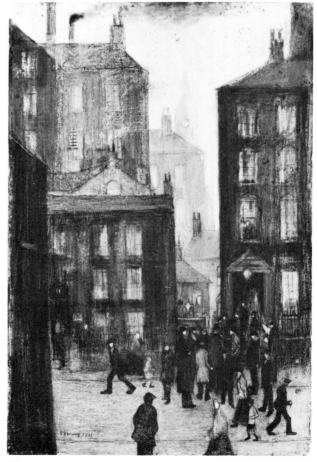

53

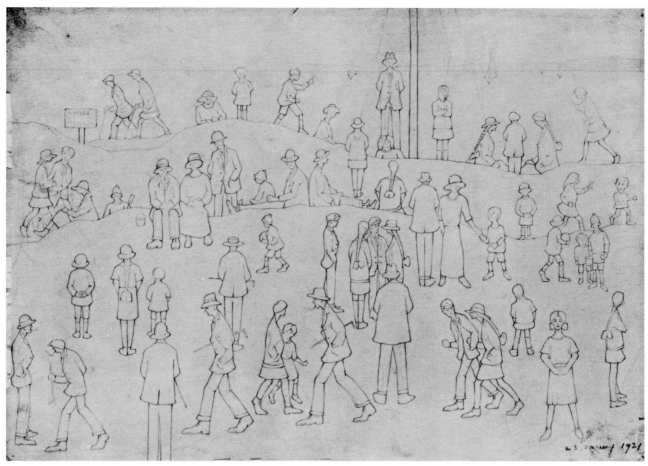

54

54 On The Sands

1921
Pencil. 27·3 × 36·7 cm
Signed: L. S. Lowry 1921
Purchased (1959–648)
Exhib: Manchester 1959, Harrogate 1960,
Nottingham 1967, Norwich 1970, Liverpool
1973, Royal Academy 1976
Illus: *Drawings of L. S. Lowry – Public and Private*

This is the best example in the Salford Collection
of a picture illustrating the artist's carefully
detailed studies of crowd scenes. At this time
Lowry concentrated on the crowd using fine line
but his figures were soon to be stylized and
incorporated into his major industrial paintings.

55 Woman in a Chair

1921 (and 1956)
Oil on panel. 41·8 × 34·0 cm
Unsigned
Purchased (1959–634)
Exhib: Manchester 1959, Liverpool 1973

Although painted from life in 1921 the
background was repainted by the artist in 1956.

56 Regent Street, Lytham *Colour Plate*

1922
Oil on board. 25·6 × 35·6 cm
Signed: L. S. Lowry 1922
Lowry bequest (1971–192)

See No.42.

57 Swinton Moss

*c.*1922
Oil on board. 14·0 × 19·5 cm
Signed: L. S. Lowry
Presented by the artist (1974–100)
Swinton Collection
Exhib: Royal Academy 1976 (dated as *c.*1922)

During the 1920s, Mr Lowry often sketched on
the mosslands around Swinton. Some of the
sketches, several of which are in the Salford
Collection, were used for paintings.

58 On the Moss

1923
Pencil. 26·5 × 37·5 cm
Signed: L. S. Lowry 1923
Purchased from the artist (1974–98)
Swinton Collection
Exhib: Sheffield 1962
Illus: *Drawings of L. S. Lowry – Public and Private*

59 River Irwell at the Adelphi

1924
Pencil. 35·5 × 52·3 cm
Signed: L. S. Lowry 1924
Presented by the artist (1958–5)
Exhib: Nottingham 1967, Royal Academy 1976
Illus: *Drawings of L. S. Lowry – Public and Private*

This drawing is reminiscent of a number of the
artist's later composite paintings epitomizing the
industrial scene. Compare 'The Lake' 1937
(No.120).

60 Bandstand, Peel Park

1924
Pencil. 17·1 × 24·5 cm
Signed: L. S. Lowry 1924
Purchased from the artist (1951–16)
Exhib: Nottingham 1967
Illus: *Drawings of L. S. Lowry – Public and Private*

See No.45.

61 View from a Window of the Royal Technical College, Salford, Looking Towards Manchester

1924
Pencil. 55·5 × 37·5 cm
Signed: L. S. Lowry 1924
Purchased from the artist (1952–37)
Exhib: Norwich 1970, Nottingham 1974
Illus: *Drawings of L. S. Lowry – Public and Private*

See Nos.45, 62 and 64.

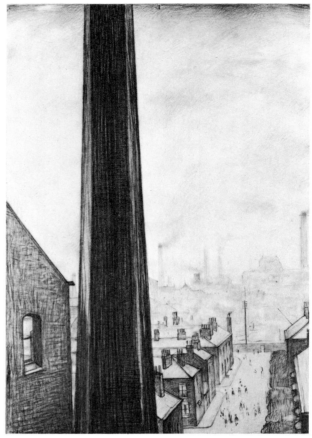

62

62 View from a Window of the Royal Technical College, Salford

1924
Pencil. 54·4 × 37·5 cm
Signed: L. S. Lowry 1924
Presented by the artist (1951–17)
Exhib: Manchester 1959, Harrogate 1960, Arts
Council 1966, Norwich 1970, Nottingham 1974,
Royal Academy 1976
Illus: *Drawings of L. S. Lowry – Public and Private*

See Nos.45, 61 and 64. A fine drawing of a view
familiar to Mr Lowry and many other Salford
Art School students.

63 Untitled (Street Scene)

1924
Pencil. 25·3 × 35·6 cm
Signed: L. S. Lowry 1924
Purchased (1959–653)

On reverse of 'Houses in Broughton' (No.121).

64 View from a Window of the Royal Technical College, Salford, Looking Towards Broughton

1925
Pencil. 26·5 × 36·5 cm
Signed: L. S. Lowry 1925
Purchased from the artist (1952–36)
Exhib: Arts Council 1966, Nottingham 1967,
Norwich 1970, Liverpool 1973, Royal Academy
1976
Illus: *Drawings of L. S. Lowry – Public and Private*

See Nos.45, 61 and 62.

65 Self-Portrait *Colour Plate*

1925
Oil on board. 57·2 × 47·2 cm
Signed: L. S. Lowry 1925
Purchased (1959–635)
Exhib: Manchester 1959, Harrogate 1960, Arts
Council 1966, Nottingham 1967, Arts Council
1970, Liverpool 1973, Royal Academy 1976
Illus: *Paintings of L. S. Lowry*

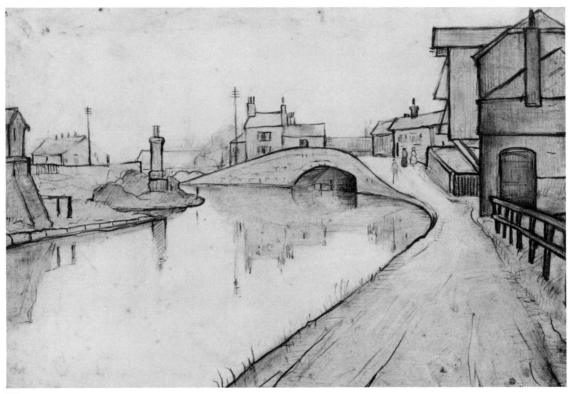

66

66 Canal at Worsley

1925
Pencil. 24·2 × 34·5 cm
Signed: L. S. Lowry 1925
Purchased from the artist (1974–97)
Swinton Collection
Illus: *Drawings of L. S. Lowry – Public and Private*

This and the following two drawings are
believed to be the only views of Worsley Village
undertaken by the artist.

67 Worsley – Canal Scene (View of Packet House)

1925
Pencil. 24·5 × 34·5 cm
Signed: L. S. L. 1925
Purchased from the artist (1974–91)
Swinton Collection
Illus: *Drawings of L. S. Lowry – Public and Private*

68 Worsley (Iron Bridge)

1925
Pencil. 24·6 × 34·7 cm
Signed: L. S. L. 1925
Purchased from the artist (1974–85)
Swinton Collection
Illus: *Drawings of L. S. Lowry – Public and Private*

69 Dixon Fold

1925
Pencil. 24·5 × 34·8 cm
Signed: L. S. Lowry 1925
Purchased from the artist (1974–95)
Swinton Collection
Exhib: Sheffield 1962
Illus: *Drawings of L. S. Lowry – Public and Private*

70 Untitled (Pit-head Scene, Wet Earth)

1925
Pencil. 21·6 × 34·8 cm
Signed: L. S. Lowry 1925
Purchased from the artist (1974–83)
Swinton Collection
Exhib: Sheffield 1962

One of only three paintings and several drawings by the artist depicting colliery scenes. See Nos.50 and 106.

71 Old Farm in Pendlebury

1925
Pencil. 24·0 × 33·5 cm
Signed: L. S. Lowry 1925
Purchased from the artist (1974–89)
Swinton Collection
Exhib: Sheffield 1962, Royal Academy 1976
Illus: *Drawings of L. S. Lowry – Public and Private*

72 Country Road

1925
Pencil. 24·5 × 34·7 cm
Signed: L.S.L. 1925
Purchased (1959–649)
Exhib: Manchester 1959, Arts Council 1966, Nottingham 1967, Norwich 1970
Illus: *Drawings of L. S. Lowry – Public and Private*

See No.42.

73 Country Road near Lytham

1925
Pencil. 25·6 × 35·6 cm
Signed: L. S. Lowry '25
Presented by V. G. Funduklian (1974–18)
Illus: *Drawings of L. S. Lowry – Public and Private*

Below the signature is the inscription 'St. Annes'.
See No.42.

74 Bandstand, Peel Park, Salford

1925
Pencil. 36·7 × 54·6 cm
Signed: L. S. Lowry 1925
Presented by the artist (1951–16)
Exhib: Wakefield 1955, Manchester 1959, Arts Council 1966, Liverpool 1973, Nottingham 1974
Illus: *Drawings of L. S. Lowry – Public and Private*

See No.45. This was used as a study for an oil painting in the collection of the City Art Gallery, York, of the same title but dated 1931.

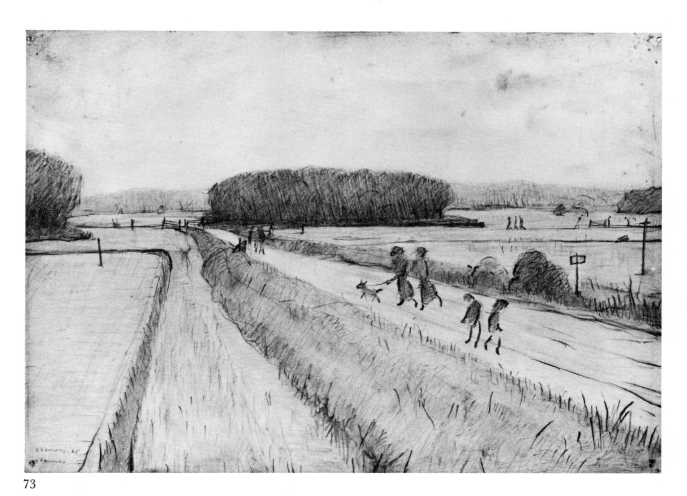

73

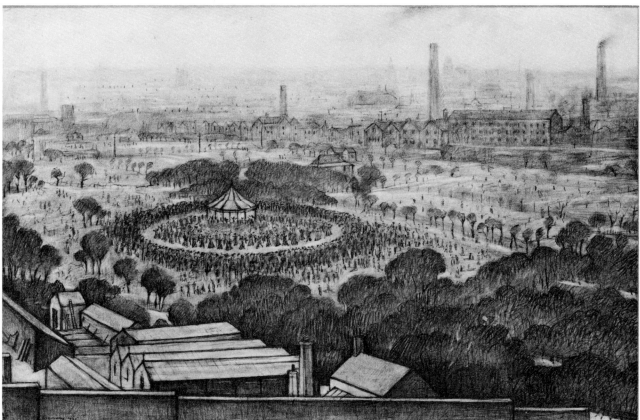

74

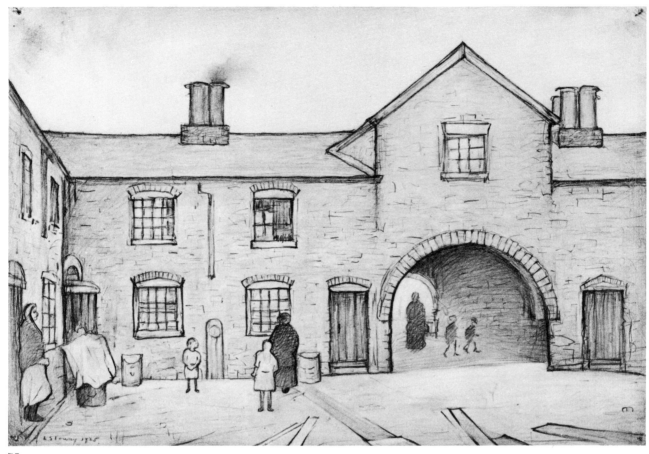

75

75 Old Houses, Flint

1925
Pencil. 25·6 × 35·8 cm
Signed: L. S. Lowry 1925
Purchased (1959–650)
Exhib: Manchester 1959, Nottingham 1967,
Norwich 1970
Illus: *Drawings of L. S. Lowry – Public and Private*

L. S. Lowry never travelled abroad but claimed
to have visited all parts of the British Isles. This
drawing is one of many scenes which were
completed from holiday sketches.

76 Belle Vue House, Leaf Square, Salford

1925
Pencil. 24·0 × 34·7 cm
Signed: L. S. Lowry 1925
Presented by the artist (1951–20)
Exhib: Manchester 1959, Norwich 1970
Illus: *Drawings of L. S. Lowry – Public and Private*

77 Behind Leaf Square (2)

1925
Pencil. 24·5 × 35·0 cm
Signed: L. S. Lowry 1925
Purchased from the artist (1952–29)
Illus: *Drawings of L. S. Lowry – Public and Private*

78 Behind Leaf Square (3)

1925
Pencil. 24·5 × 34·8 cm
Signed: L. S. Lowry 1925
Purchased from the artist (1952–30)
Illus: *Drawings of L. S. Lowry – Public and Private*

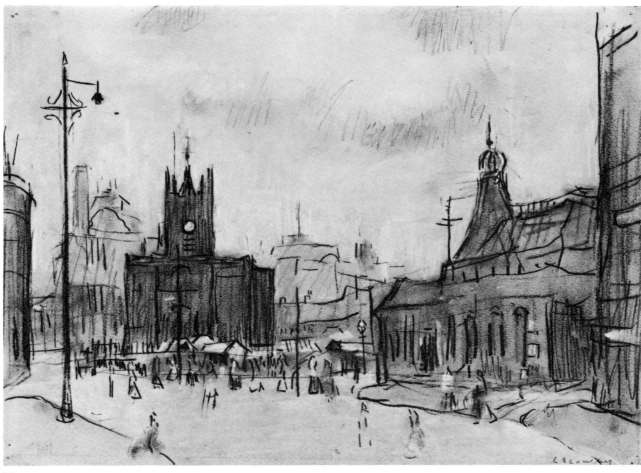

79

79 The Flat-iron Market

*c.*1925
Pencil. 28·3 × 38·3 cm
Signed: L. S. Lowry
Presented by the artist (1951–19)
Exhib: Wakefield 1955, Norwich 1970, Royal
Academy 1976
Illus: *Drawings of L. S. Lowry*

80 Bridge with Figures over Colliery Railway

*c.*1925
Pencil. 37·0 × 55·0 cm
Signed: L. S. Lowry
Presented by the artist (1974–99)
Swinton Collection
Exhib: Sheffield 1962, Arts Council 1966,
Royal Academy 1976
Illus: *Drawings of L. S. Lowry – Public and Private*

This drawing was executed at a time when Mr
Lowry sketched on the mosslands around
Swinton with a companion.

81 Rhyl Harbour

*c.*1925
Pencil. 21·6 × 36·6 cm
Signed: L. S. Lowry
Presented by V. G. Funduklian (1974–16)
Illus: *Drawings of L. S. Lowry – Public and Private*

82 Behind Leaf Square (1)

1926
Pencil. 25·0 × 35·5 cm
Signed: L. S. Lowry 1926
Purchased from the artist (1952–28)
Exhib: Manchester 1959
Illus: *Drawings of L. S. Lowry – Public and Private*

83 Behind Leaf Square (4)

1926
Pencil. 35·3 × 26·1 cm
Signed: L.S.L. 1926
Purchased from the artist (1952–31)
Illus: *Drawings of L. S. Lowry – Public and Private*

Inscribed on the picture is 'An Old Lamp'

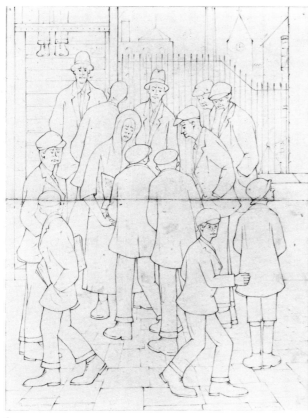

84

84 The Mid-Day Special

1926
Pencil. 38·4 × 27·8 cm
Signed: L. S. Lowry 1926 'The Mid-Day
Special'
Presented by the artist (1959–567)
Exhib: Nottingham 1967, Norwich 1970
Illus: *Drawings of L. S. Lowry – Public and Private*

Very similar in composition to 'The Result of
the Race' in the collections of the City Art
Gallery, Manchester.

85 By Christ Church, Salford

1926
Pencil. 35·5 × 25·3 cm
Signed: L. S. Lowry 1926
Presented by the artist (1951–21)
Exhib: Manchester 1959
Illus: *Drawings of L. S. Lowry – Public and Private*

86 House on Botany (Clifton)

1926
Pencil. 22·0 × 35·5 cm
Signed: L. S. Lowry 1926
Purchased from the artist (1974–86)
Swinton Collection
Exhib: Sheffield 1962
Illus: *Drawings of L. S. Lowry – Public and Private*

87 The Post Office

1926
Pencil. 27·0 × 37·3 cm
Signed: L. S. Lowry 1926
Purchased (1959–651)
Exhib: Manchester 1959, Nottingham 1967,
Norwich 1970, Royal Academy 1976
Illus: *Drawings of L. S. Lowry – Public and Private*
(wrongly called 'Waiting for the Newspapers')

88 The Tower

1926
Pencil. 35·5 × 25·3 cm
Signed: L.S.L. 1926
Purchased (1959–652)
Exhib: Manchester 1959, Norwich 1970
Illus: *Drawings of L. S. Lowry – Public and Private*

89 By St. Philip's Church, Salford

1926
Pencil. 25·2 × 35·3 cm
Signed: L. S. Lowry 1926
Purchased from the artist (1952–33)
Exhib: Norwich 1970, Liverpool 1973
Illus: *Drawings of L. S. Lowry – Public and Private*

90 By the County Court, Salford

1926
Pencil. 24·6 × 34·9 cm
Signed: L.S.L. 1926
Presented by the artist (1951–18)
Exhib: Nottingham 1967, Norwich 1970
Illus: *Drawings of L. S. Lowry – Public and Private*

91 Peel Park, Salford

1927
Oil on board. 35·0 × 50·0 cm
Signed: L. S. Lowry 1927
Purchased (1951–14)
Exhib: Wakefield 1955, Harrogate 1960, Arts
Council 1966, Nottingham 1967, Arts Council
1970, Liverpool 1973, Nottingham 1974, Royal
Academy 1976
Illus: *Paintings of L. S. Lowry*

See No.45. This is a side view of the Salford Art
Gallery and entrance to the Central Library
viewed from the Salford Technical College
where L. S. Lowry attended art classes. See
Nos.94–6 sketches for this painting.

92 St Simon's Church (A Street Scene – St Simon's Church)

1927
Pencil. 38·4 × 29·3 cm
Signed: L. S. Lowry 1927
Presented by the artist (1951–15)
Exhib: Nottingham 1967, Norwich 1970, Belfast 1971, Liverpool 1973, Nottingham 1974
Illus: *Drawings of L. S. Lowry – Public and Private*

The drawing which the artist used for his painting of the same subject in 1928 (see No. 102). Lowry said of this drawing 'I did it just in time, St Simon's was knocked down in 1928'.

93 The Terrace, Peel Park

1927
Pencil. 26·0 × 35·8 cm
Signed: L. S. Lowry 1927
Purchased (1960–500)
Exhib: Arts Council 1966, Nottingham 1967, Norwich 1970, Royal Academy 1976
Illus: *Drawings of L. S. Lowry – Public and Private*

See No. 45. This drawing was purchased from the Reid Gallery, London in 1960. On the back of the drawing is the following inscription: 'Presented to me by L. S. Lowry on 30 May 1951 on occasion of my visit to Manchester. The scene is from the terrace of the Salford Art Gallery, often painted by Lowry. Maurice Collis.'

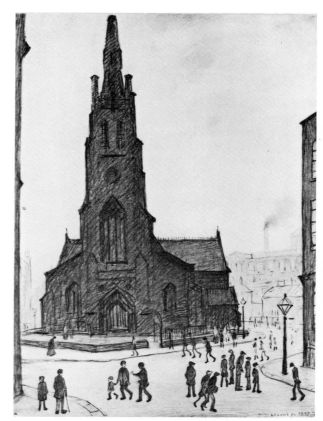

92

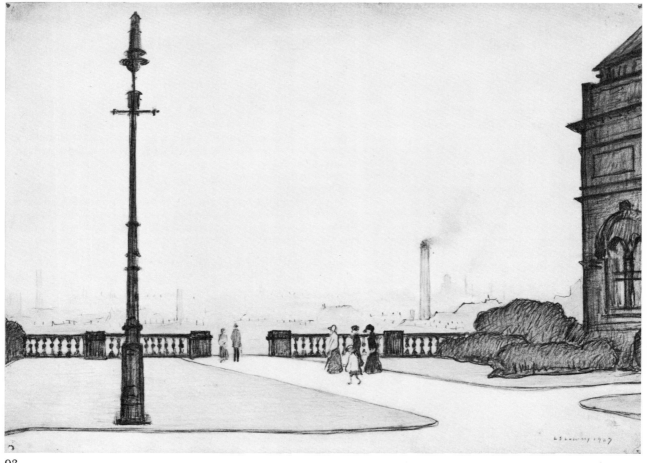

93

94 Peel Park Sketch

c.1927
Pencil. 20.0 × 12.0 cm
Unsigned
Presented by the artist (1957–156a)
Illus: *Drawings of L. S. Lowry – Public and Private*

Sketch showing view of statue and bird's-eye view of the park. This, and the two following sketches, was used for the oil painting 'Peel Park, Salford' (No.91). See No.45.

95 Peel Park Sketch

c.1927
Pencil. 20.0 × 12.0 cm
Unsigned
Presented by the artist (1957–156b)
Illus: *Drawings of L. S. Lowry – Public and Private*

Working sketch of park and art gallery. See Nos.45 and 94.

96 Peel Park Sketch

c.1927
Pencil. 20.0 × 12.0 cm
Unsigned
Presented by the artist (1957–156c)
Illus: *Drawings of L. S. Lowry – Public and Private*

Studies of the porch, window, and lamp-post. See Nos.45 and 94.

97 Sketch for 'Great Ancoats Street'

c.1927
Pencil. 11.3 × 19.7 cm
Unsigned
Presented by the artist (1957–156f)
Illus: *Drawings of L. S. Lowry – Public and Private*

A preparatory sketch for the drawing 'Great Ancoats Street' 1930 (No.112).

98 Peel Park Sketch

c.1927
Pencil. 19.4 × 11.5 cm
Unsigned
Presented by the artist (1957–156d)
Illus: *Drawings of L. S. Lowry – Public and Private*

View of the steps from the park to the art gallery. See No.45.

99 Peel Park Sketch

c.1927
Pencil. 11.3 × 19.7 cm
Unsigned
Presented by the artist (1957–156e)
Illus: *Drawings of L. S. Lowry – Public and Private*

View of the park looking towards the steps. See No.45.

100 Bandstand, Peel Park, Salford

1928
Oil on board. 29.2 × 39.2 cm
Signed: L. S. Lowry 1928
Purchased (1963–71)
Monks Hall Museum Collection
Exhib: Sheffield 1962, Liverpool 1973

See No.45.

101 Ringley

1928
Pencil. 26.4 × 38.5 cm
Signed: L. S. Lowry 1928
Purchased from the artist (1974–82)
Swinton Collection
Exhib: Sheffield 1962
Illus: *Drawings of L. S. Lowry – Public and Private*

This was a favourite spot when the Irwell valley attracted sightseers from afar.

102 A Street Scene – St Simon's Church

1928
Oil on board. 43.8 × 38.0 cm
Signed: L. S. Lowry 1928
Purchased (1936–2)
Exhib: Manchester 1959, Harrogate 1960, Arts Council 1966, Nottingham 1967, Arts Council 1970, Belfast 1971, Liverpool 1973, Nottingham 1974
Illus: *Paintings of L. S. Lowry*

This was the first L. S. Lowry picture to be acquired by Salford Art Gallery. The painting was purchased from the Spring Exhibition of the Manchester Academy of Fine Arts, held at the City Art Gallery, Manchester in March 1936. See No.92 – drawing of the same subject.

103 View from Morton Moss

c.1928
Pencil. 10.2 × 13.0 cm
Signed: LSL
Presented by G. B. Cotton (1974–87)
Swinton Collection
Illus: *Drawings of L. S. Lowry – Public and Private*

104 Newtown Mill and Bowling Green

c.1928
Pencil. 24·6 × 35·0 cm
Signed: L. S. Lowry
Acquired from G. B. Cotton (1974–81)
Swinton Collection

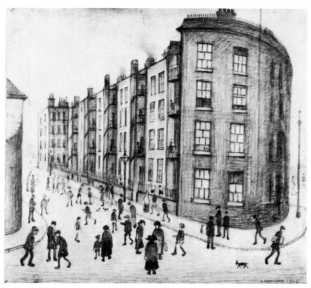

105

105 Oldfield Road Dwellings

1929
Pencil. 41·2 × 43·8 cm
Signed: L. S. Lowry 1929
Presented by the artist (1957–155)
Exhib: Harrogate 1960, Arts Council 1966,
Norwich 1970, Nottingham 1974
Illus: *Drawings of L. S. Lowry – Public and Private*

A view of the workmen's flats which used to
stand near the junction of Oldfield Road with
Chapel Street. The drawing was used as a model
for an oil painting which hangs in the Tate
Gallery, London (see No.74, Royal Academy
catalogue).

106 Wet Earth Colliery, Dixon Fold

1929
Pencil. 24·3 × 34·5 cm
Signed: L. S. Lowry 1929
Purchased from the artist (1952–32)
Exhib: Manchester 1959, Sheffield 1962,
Norwich 1970, Liverpool 1973
Illus: *Drawings of L. S. Lowry – Public and Private*

See No.70.

107 Clifton Moss Farm

1929
Pencil. 17·0 × 12·0 cm
Signed: LSL 1929
Presented by the Friends of the Salford Museums
(F8–1976)

108 Coming from the Mill *Colour Plate*

1930
Oil on canvas. 42·0 × 52·0 cm
Signed: L. S. Lowry 1930
Purchased from the artist (1941–8)
Exhib: Wakefield 1955, Manchester 1959,
Nottingham 1967, Norwich 1970, Nottingham
1974, Royal Academy 1976
Illus: *Royal Academy Catalogue*
 Paintings of L. S. Lowry

This painting was based on a much earlier
pastel drawing dating from 1917–18 (No.41)
and shows the contrast in style since that date.
In a letter to the gallery Lowry wrote: 'It gives
me great pleasure that Salford have bought
(this) picture – for I have always thought it was
my most characteristic mill scene.'

109 The Gamekeeper's Cottage, Swinton Moss

1930
Pencil. 25·0 × 37·0 cm
Signed: L. S. Lowry 1930
Purchased from the artist (1974–94)
Swinton Collection
Exhib: Sheffield 1962, Royal Academy 1976
Illus: *Drawings of L. S. Lowry – Public and Private*

110 Untitled (Swinton Industrial Schools)

1930
Pencil. 27·3 × 36·4 cm
Signed: L. S. Lowry 1930
Purchased from the artist (1974–92)
Swinton Collection
Exhib: Sheffield 1962
Illus: *Drawings of L. S. Lowry – Public and Private*

111 St Augustine's Church, Pendlebury

1930
Pencil. 35·1 × 26·0 cm
Signed: L. S. Lowry 1930
Purchased from the artist (1952–27)
Exhib: Nottingham 1974
Illus: *Drawings of L. S. Lowry – Public and Private*

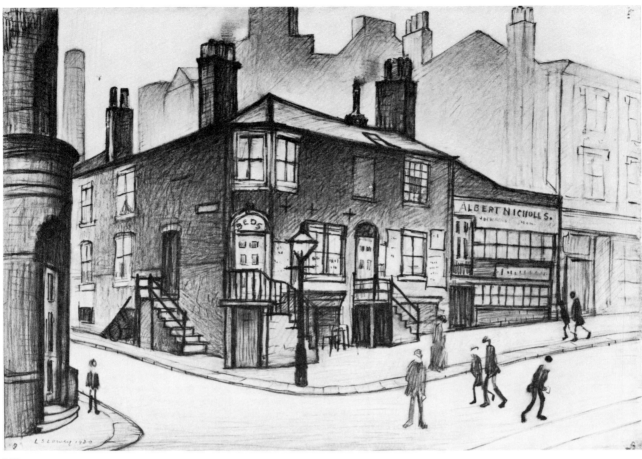

112

112 Great Ancoats Street, Manchester

1930
Pencil. 28·0 × 38·4 cm
Signed: L. S. Lowry 1930
Purchased (1951–23)
Exhib: Nottingham 1967, Norwich 1970,
Belfast 1971, Nottingham 1974
Illus: *Drawings of L. S. Lowry – Public and Private*

See sketch No.97.

113 Farm on Wardley Moss

1930
Pencil. 12·2 × 17·7 cm
Signed: L. S. Lowry 1930
Presented by G. B. Cotton (1974–88)
Swinton Collection
Exhib: Royal Academy 1976
Illus: *Drawings of L. S. Lowry – Public and Private*

114 The Steps, Peel Park

1930
Pencil. 38·5 × 27·0 cm
Signed: L. S. Lowry 1930 'The Steps, Peel Park'
Purchased from the artist (1952–35)
Exhib: Nottingham 1967, Norwich 1970,
Nottingham 1974, Royal Academy 1976
Illus: *Drawings of L. S. Lowry – Public and Private*

See No.45.

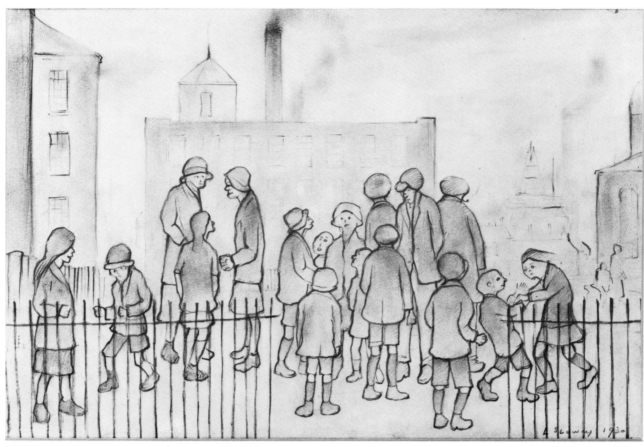

115

115 Waiting for the Newspapers

1930
Pencil. 24·1 × 24·3 cm
Signed: L. S. Lowry 1930
Purchased (1960–501)
Exhib: Nottingham 1967, Norwich 1970, Belfast
1971, Liverpool 1973
Illus: *Drawings of L. S. Lowry – Public and Private*

116 Rear of Property on Bolton Road, Pendlebury

*c.*1930
Pencil. 26·0 × 36·2 cm
Signed: L. S. Lowry
Presented by G. B. Cotton (1974–93)
Swinton Collection
(See No.11).

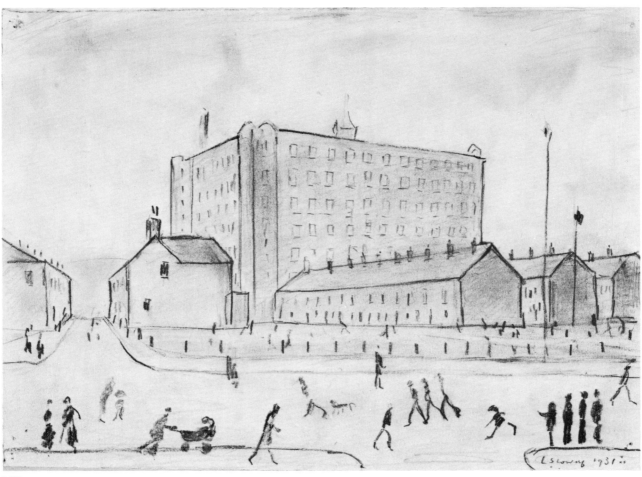

117

117 Pendlebury Scene

1931
Pencil. 28·3 × 37·8 cm
Signed: L. S. Lowry 1931
Acquired from G. B. Cotton (1974–96)
Swinton Collection
Exhib: Royal Academy 1976
Illus: *Drawings of L. S. Lowry – Public and Private*

The artist stated that this area (including Acme
Mill) originally evoked his interest in the
industrial scene. On the reverse is a life drawing
c.1917 (see No.40).

118 A Fight *Colour Plate*

1935
Oil on canvas. 53·2 × 39·5 cm
Signed: L. S. Lowry
Purchased (1959–642)
Exhib: Royal Academy 1959, Harrogate 1960,
Nottingham 1967, Nottingham 1974, Royal
Academy 1976
Illus: *Royal Academy Catalogue*
 Paintings of L. S. Lowry

Lowry witnessed this scene outside a lodging
house in Manchester. A drawing in the
collections of the City Art Gallery, Manchester,
dated two years later, has only slight differences.

119 A Landmark *Colour Plate*

1936
Oil on canvas. 43·4 × 53·6 cm
Signed: L. S. Lowry 1936
Purchased (1959–636)
Illus: *Paintings of L. S. Lowry*

The artist's interpretation of the country
landscape changed in style after the mid-1920s
and the contrast between his early landscapes
(Nos.19, 28, 42, etc.) and his later 'lonely
landscapes' is just as marked as the difference is
between his treatment of people and the
industrial scene after this period of development.
This is the earliest 'lonely landscape' in the
Salford Collection. See also Nos.130–132.

120 The Lake *Colour Plate*

1937
Oil on canvas. 43·4 × 53·5 cm
Signed: L. S. Lowry 1937
Purchased (1939–19)
Exhib: Belfast 1951, Manchester 1959, Sheffield
1962, Nottingham 1967, Norwich 1970,
Liverpool 1973

A classic example of the artist's technique
whereby he created composite pictures which
symbolized the industrial north of the 1930s.
See No.59.

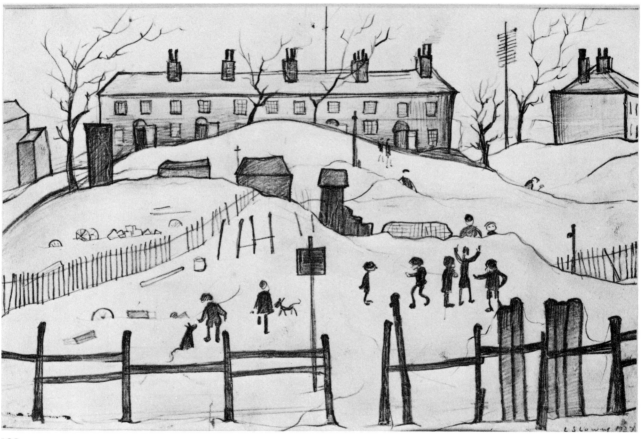

121

121 Houses in Broughton

1937
Pencil. 25·3 × 35·6 cm
Signed: L. S. Lowry 1937
Purchased (1959–653)
Exhib: Manchester 1959, Harrogate 1960,
Nottingham 1967, Norwich 1970, Belfast 1971
Illus: *Drawings of L. S. Lowry – Public and Private*

On reverse is an untitled scene dated 1924 (see
No.63).

122 Head of a Man *Colour Plate*

1938
Oil on canvas. 50·7 × 41·0 cm
Signed: L. S. Lowry 1938
Purchased (1959–637)
Exhib: Wakefield 1955, Manchester 1959,
Harrogate 1960, Arts Council 1966, Nottingham
1967, Norwich 1970, Nottingham 1974, Royal
Academy 1976
Illus: *Paintings of L. S. Lowry*

See No.25. Also called 'Portrait' and 'Head of a
Man with Red Eyes'. One of the finest examples
of the artist's imaginative portraits. This
painting was executed shortly before the death
of his mother and conveys his extreme
emotional stress at the time.

123 Market Scene, Northern Town *Colour Plate*

1939
Oil on canvas. 45·7 × 61·1 cm
Signed: L. S. Lowry 1939
Presented by the artist (1942–1)
Exhib: Belfast 1951, Manchester 1959,
Harrogate 1960, Belfast 1971, Liverpool 1973
Illus: *Paintings of L. S. Lowry*

A composite picture said to have been based on
Pendlebury Market which is situated close to
Mr Lowry's former home at Station Road.

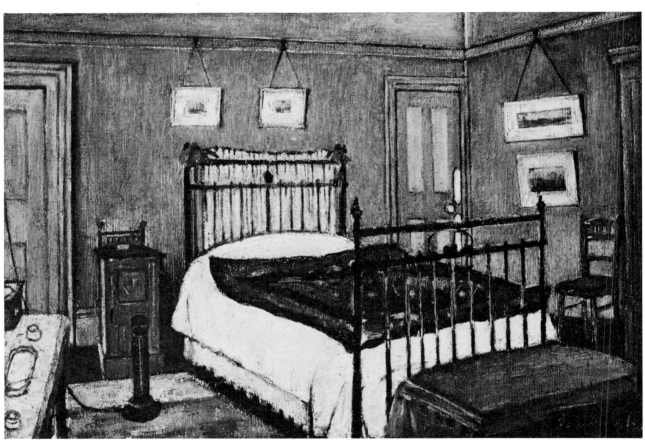

124

124 The Artist's Bedroom, Pendlebury

1940
Oil on canvas. 35·8 × 51·2 cm
Signed: L. S. Lowry 1940
Lowry bequest (1971–191)
Exhib: Liverpool 1973
Illus: *Paintings of L. S. Lowry*

This picture was entitled 'The Bedroom' until
the artist's death, in respect of his wishes that it
should not be generally known that it did, in
fact, depict his own bedroom at Station Road.

125 Blitzed Site

1942
Oil on canvas. 39·2 × 49·4 cm
Signed: L. S. Lowry 1942
Purchased (1959–638)
Exhib: Nottingham 1967
Illus: *Paintings of L. S. Lowry*

One of the artist's rare interpretations of the
wartime scene.

126 An Old Farm

1943
Oil on board. 28·5 × 37·9 cm
Signed: L. S. Lowry 1943
Purchased (1959–639)
Exhib: Liverpool 1973, Nottingham 1974

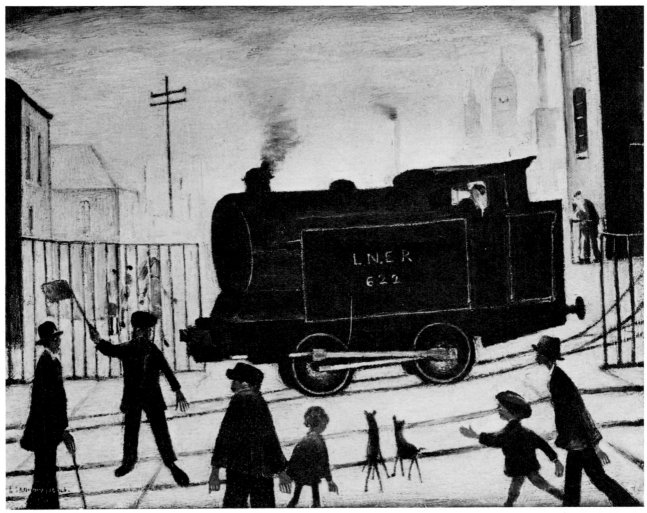

127

127 Level Crossing

1946
Oil on canvas. 46·1 × 56·1 cm
Signed: L. S. Lowry 1946
Purchased (1959–640)
Exhib: Liverpool 1973
Illus: *Paintings of L. S. Lowry*

An illustration of the artist's ability to caricature objects as well as people.

128 Dean's Mill, Swinton

*c.*1946
Pencil. 27·5 × 37·5 cm
Signed: L. S. Lowry
Purchased from the artist (1974–101)
Swinton Collection
Illus: *Drawings of L. S. Lowry – Public and Private*
(dated as 1956)

One of three pictures commissioned from the artist by the owners of the mill.

129 The Cripples *Colour Plate*

1949
Oil on canvas. 76·3 × 101·8 cm
Signed: L. S. Lowry 1949
Purchased (1959–641)
Exhib: Harrogate 1960, Arts Council 1966,
Nottingham 1967, Royal Academy 1976
Illus: *Royal Academy Catalogue*
 Paintings of L. S. Lowry

The artist has grouped together a number of cripples he knew by sight in the Manchester area in order to make a powerful statement on their physical condition.

130 House on the Moor

1950
Oil on canvas. 49·0 × 59·5 cm
Signed: L. S. Lowry 1950
Purchased (1959–643)
Exhib: Harrogate 1960, Sheffield 1962, Arts
Council 1966, Nottingham 1967, Crane Kalman
Gallery 1968, Norwich 1970, Royal Academy
1976
Illus: *Royal Academy Catalogue*
Paintings of L. S. Lowry

Mr Lowry indicated to the organizers of the
Kalman Gallery exhibition that this picture
epitomized the mood of his 'lonely landscapes'.
See also Nos.119, 131 and 132.

131 The Lake

1951
Oil on hardboard. 19·1 × 47·3 cm
Signed: L. S. Lowry 1951
Purchased (1959–646)
Exhib: Norwich 1970, Liverpool 1973

See also Nos.119, 130 and 132.

134 The Funeral Party *Colour Plate*

1953
Oil on canvas. 76·1 × 102·0 cm
Signed: L. S. Lowry 1953
Purchased (1959–644)
Exhib: Harrogate 1960, Nottingham 1967,
Norwich 1970, Liverpool 1973
Illus: *Paintings of L. S. Lowry*

See No.52. Mr Lowry was a keen observer of
people and he saw humour in their odd
behaviour and obviously enjoyed recording such
incidents (see also Nos.118, 135 and 147). He
has composed an amusing situation in this
picture and used to relish explaining that the
man on the far right is being treated as an
outcast for coming to the funeral in boots and a
red tie.

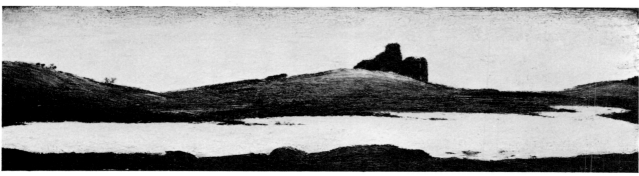

132

132 Landscape in Cumberland

1951
Oil on board. 15·9 × 58·7 cm
Signed: L. S. Lowry 1951
Purchased (1959–645)
Exhib: Norwich 1970, Liverpool 1973

See also Nos.119, 130 and 131.

133 Seascape

1952
Oil on canvas. 39·5 × 49·3 cm
Signed: L. S. Lowry 1952
Purchased from the artist (1954–152)
Exhib: Liverpool 1973, Nottingham 1974

Purchased from a 'Lancashire Scene' exhibition
held at Salford Art Gallery in September–
October 1954. The artist was always pleased to
see this painting on his visits to the gallery where
he would single it out for special attention.

135 Family Group

1956
Pencil. 25·5 × 35·5 cm
Signed: L. S. Lowry 1956
Purchased (1959–654)
Exhib: Manchester 1959, Norwich 1970,
Liverpool 1973
Illus: *Drawings of L. S. Lowry – Public and Private*

See Nos.52, 118, 134 and 147.

136 Christ Church, Salford (1)

1956
Pencil. 33·0 × 23·7 cm
Signed: L. S. Lowry 1956
Purchased from the artist (1956–323)
Illus: *Drawings of L. S. Lowry – Public and Private*

This drawing and that following, were made
from sketches taken on the same day. The artist
expressed a preference for this version and only
gave the second drawing at a later date.

137 Christ Church, Salford (2)

1956
Pencil. 24·3 × 33·6 cm
Signed: L. S. Lowry 1956
Presented by the artist (1957–51)
Illus: *Drawings of L. S. Lowry – Public and Private*

See No. 136.

138 St Stephen's Church, Salford (2)

1956
Pencil. 24·3 × 35·2 cm
Signed: L. S. Lowry 1956
Presented by the artist (1959–659)
Illus: *Drawings of L. S. Lowry – Public and Private*

The artist was asked if he would record some of
the Trinity and St Matthias' areas of Salford
before they were redeveloped and this picture
together with Nos. 139–41 were drawn from
sketches made on the spot in the spring of 1956.

139 Chapel, St Stephen's Street, Salford

1956
Pencil. 24·3 × 33·9 cm
Signed: L. S. Lowry 1956
Presented by the artist (1957–52)
Illus: *Drawings of L. S. Lowry – Public and Private*

141 Francis Terrace, Salford

1956
Pencil. 25·3 × 34·9 cm
Signed: L. S. Lowry 1956
Purchased from the artist (1957–53)
Exhib: Harrogate 1960, Arts Council 1966,
Nottingham 1967, Norwich 1970, Royal
Academy 1976
Illus: *Drawings of L. S. Lowry – Public and Private*

142 Boats

1956
Pencil. 24·0 × 33·6 cm
Signed: L. S. Lowry 1956
Presented by V. G. Funduklian (1974–17)
Exhib: Royal Academy 1976
Illus: *Drawings of L. S. Lowry – Public and Private*

143 The Estuary

1956–59
Watercolour. 24·0 × 34·2 cm
Signed: L. S. Lowry 1956 finished in 1959
Purchased from the artist (1959–657)

The artist recalled that the watercolours in the
Salford Collection were from a group of 'no
more than a dozen' paintings which comprised
his total output in this medium.

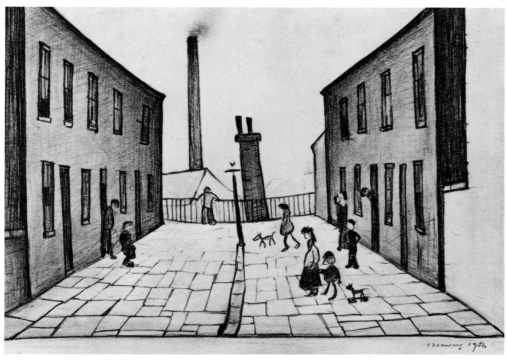

140

140 North James Henry Street, Salford

1956
Pencil. 24·4 × 33·7 cm
Signed: L. S. Lowry 1956
Purchased from the artist (1957–54)
Exhib: Norwich 1970, Liverpool 1973
Illus: *Drawings of L. S. Lowry – Public and Private*

144 St Stephen's Church, Salford 3 (1)

1957
Pencil. 35·0 × 24·5 cm
Signed: L. S. Lowry 1957
Presented by the artist (1957–50)
Exhib: Arts Council 1966, Nottingham 1967
Illus: *Drawings of L. S. Lowry – Public and Private*

145 Richmond Hill

1957
Pencil. 34·6 × 24·4 cm
Signed: L. S. Lowry 1957 'From an old sketch
1924'
Presented by the artist (1957–154)
Illus: *Drawings of L. S. Lowry – Public and Private*

A Salford scene which illustrates the artist's use
of old sketches to make new pictures. See
No.108 – another example of this technique.

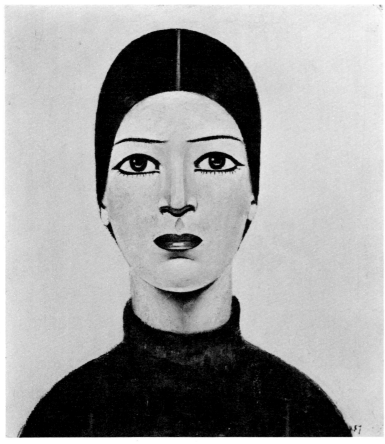

146

146 Portrait of Ann

1957
Oil on board. 38·6 × 33·3 cm
Signed: L. S. Lowry 1957
Presented by the artist (1960–347)
Exhib: Nottingham 1967, Norwich 1970
Illus: *Paintings of L. S. Lowry*

One of a group of pencil studies and paintings of
this subject. See No.226, Royal Academy
catalogue.

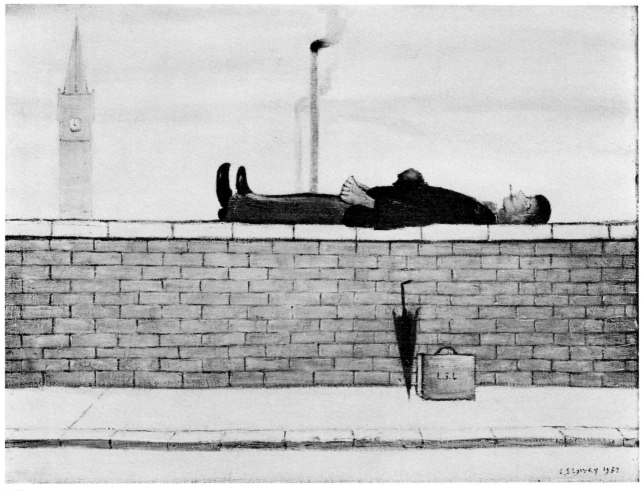

147

147 Man Lying on a Wall

1957
Oil on canvas. 40·7 × 50·9 cm
Signed: L. S. Lowry 1957
Purchased (1959–647)
Exhib: Manchester 1959, Harrogate 1960,
Sheffield 1962, Arts Council 1966, Nottingham
1967, Nottingham 1974
Illus: *Paintings of L. S. Lowry*

This is Lowry's interpretation of an actual
situation. His amusement is obvious; his
approval is indicated by his own initials on the
attaché case. See also Nos. 118 and 134.

148 The Street

1958
Pencil. 25·0 × 34·5 cm
Signed: L. S. Lowry 1958
On indefinite loan from Pendleton High School
Parent Teacher Association
Illus: *Drawings of L. S. Lowry – Public and Private*

149 Going to Work

1959
Watercolour. 27·0 × 38·5 cm
Signed: L. S. Lowry 1959
Purchased from the artist (1959–658)
Exhib: Harrogate 1960, Norwich 1970
Illus: *Paintings of L. S. Lowry*

See No. 143.

150 Group of People *Colour Plate*

1959
Watercolour. 35·6 × 25·5 cm
Signed: L. S. Lowry 19th August 1959
Purchased from the artist (1959–656)
Exhib: Harrogate 1960, Norwich 1970
Illus: *Paintings of L. S. Lowry*

See No. 143.

151 Yachts

1959
Watercolour. 26·0 × 36·2 cm
Signed: L. S. Lowry 1959
Purchased from the artist (1959–655)
Exhib: Royal Academy 1976

See No.143.

152 Mill Scene *Colour Plate*

1959
Oil on canvas. 30·5 × 41·0 cm
Signed: L. S. Lowry 1959

On indefinite loan from Glossop School Parent
Teachers Association

153 Untitled (Head of a Man)

*c.*1959
Watercolour. 35·6 × 25·5 cm
Unsigned
Purchased from the artist (1959–656a)
On reverse of 150 'Group of People'

See No.143.

154 Gentleman Looking at Something

1960
Oil on board. 24·5 × 10·0 cm
Signed: L. S. Lowry 1960
Purchased from the artist (1961–20)
Exhib: Liverpool 1973

The artist's small oil and pencil studies of
individual figures or small groups which
dominate the period 1950–76 are a sharp
contrast to the crowded mill scenes and
industrial landscapes of the 1930s and 1940s.
See also Nos.155 and 157.

155

155 Man in Overcoat

1960
Pencil. 30·6 × 22·6 cm
Signed: L. S. Lowry 1960
Purchased (1963–4)
Exhib: Norwich 1970
Illus: *Drawings of L. S. Lowry – Public and Private*

See No.154.

156 St Mary's Church, Swinton

1960
Oil on board. 22·0 × 14·5 cm
Signed: L. S. Lowry 1960
Presented by the artist (1974–78)
Swinton Collection

157 Two People

1962
Oil on board. 29·5 × 24·5 cm
Signed: L. S. Lowry 1962
Purchased from the artist (1963–5)
Exhib: Norwich 1970, Liverpool 1973

See No.154.

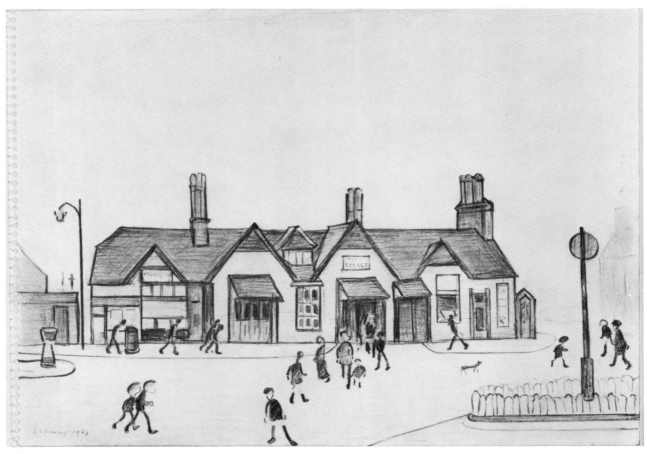

158

158 Eccles Railway Station

1963
Pencil. 25·6 × 35·6 cm
Signed: L. S. Lowry 1963
Purchased from the artist (1965–71 MH)
Monks Hall Museum Collection.

This, and the following picture, was drawn as a result of a request from the museum. The two drawings are believed to be the only Eccles scenes undertaken by Mr Lowry.

159 Eccles Town Hall

1963
Pencil. 34·3 × 24·8 cm
Signed: L. S. Lowry 1963
Presented by the artist (1965–70 MH)
Monks Hall Museum Collection.

See No.158.

160 Mill Scene

1965
Oil on canvas. 51·0 × 61·1 cm
Signed: L. S. Lowry 1965
Donated by the Swinton Memorial Fund
Committee (F144–1975)
Swinton Collection
Exhib: Royal Academy 1976

A late mill scene illustrating the change in the artist's style during his final years. Compare 'Coming from the Mill' (No.108).

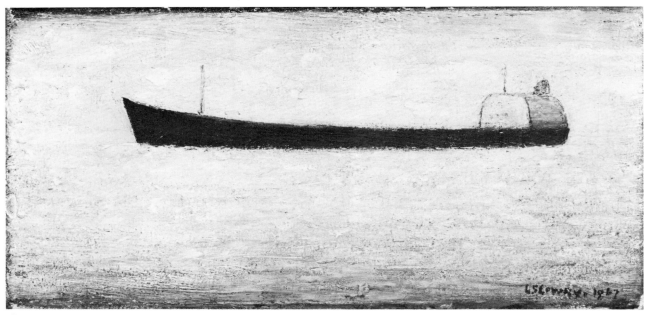

161

161 Waiting for the Tide, South Shields

1967
Oil on board. 15·1 × 30·5 cm
Signed: L. S. Lowry 1967
Purchased from the artist (1971–162)
Exhib: Liverpool 1973

In his later years, the artist frequently visited the
North-East coast with the result that there now
exist many Lowry pictures with a maritime
theme. This is not surprising as the artist showed
a recurring interest in the coastal scene (see
Nos.51, 54, 81, 133, 142, 143 and 151).